Hand made Bugs

Teresa
Terry.

SELECTED
PAINTINGS
OF
L. S. LOWRY

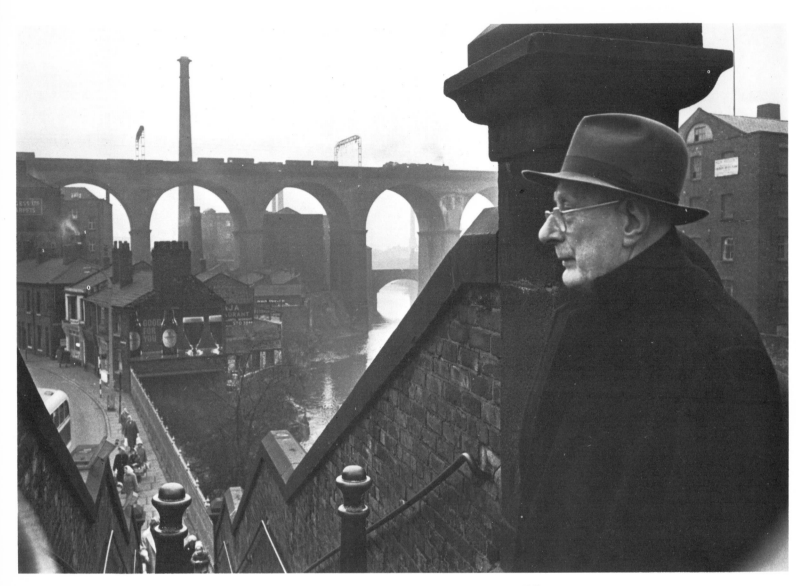

L. S. LOWRY · STOCKPORT · WINTER 1962

SELECTED PAINTINGS OF L. S. LOWRY

OILS AND WATERCOLOURS

With an Introduction and notes by MERVYN LEVY

1978
JUPITER BOOKS

FOR LEO SOLOMON

First published in 1976. Reprinted 1978.

JUPITER BOOKS (LONDON) LIMITED
167 Hermitage Road, London N4.

SBN 904041 62 X

Composed in Monophoto Bembo Series 270 by
Ramsay Typesetting (Crawley) Limited.

Printed in Great Britain by
Penshurst Press Ltd., Tunbridge Wells, Kent.

CONTENTS

In October 1975 Jupiter Books published *The Paintings of L. S. Lowry: Oils and Watercolours*, a casebound volume which contained thirty-one colour plate reproductions of L. S. Lowry's paintings and 100 monochrome reproductions, together with an Introduction by Mervyn Levy. The forty-seven colour plates of the present volume comprise the original thirty-one colour plates (Plates 1–31) with the addition of fourteen works previously reproduced monochromatically, and two further works not appearing in the earlier volume (Plates 44 and 46). The Introduction has been revised by Mr Levy in the light of Mr Lowry's death in February 1976.

ACKNOWLEDGEMENTS

The author and publishers would like to express their thanks to the late Mr L. S. Lowry for the personal assistance he rendered in the preparation of this book. They would also like to thank the following individuals and galleries, for their help, and for permission to reproduce works in their collections: the late Mr Leo Solomon; Mr Roger Birch of the Department of Photography, Rochdale College of Art; Mr Alick Leggat; Mr David Hughes; Mr Edward Goodstein; Mr Joe Fitton; Mr Bruce Sharman; Mr Norman Satinoff; Mr and Mrs Monty Bloom and Mr Martin Bloom; Mrs Angela Downs; Mr Henry Laniado; Mr John Catleugh; Mr Bobby Dimpfl; Mr Andras Kalman and the Crane Kalman Gallery, London; Mr Geoffrey Green and the Tib Lane Gallery, Manchester; Mr Stanley Shaw, Miss Marianne Hunter and the City Art Gallery, Peel Park, Salford; Mr Julian Treuherz and The City Art Gallery, Manchester; The Lefevre Gallery, London; The Tate Gallery, London; The Sunderland Art Gallery (Tyne and Wear – County Museum Service); The Castle Museum and Art Gallery, Nottingham; The City of Rochdale Art Gallery; and the Royal Academy of Arts, London. Additional thanks go also to Marie Levy.

BIOGRAPHICAL CHRONOLOGY
OF THE ARTIST

1887
Laurence Stephen Lowry born in Manchester, 1 November. Only child of R. S. Lowry an estate agent, and Elizabeth Hobson. The family lived in Rusholme, a suburb of Manchester.

1895–1904
Educated at Victoria Park School, Manchester. On leaving school he attended the private painting classes of William Fitz in Moss Side, Manchester.

1905–15
Studied drawing and painting at the Municipal College of Art, Manchester.

1909
Moved with his parents from Rusholme to 117 Station Road, Pendlebury, in Salford.

1915–20
Began to develop his interest in the industrial scene. During this period he also attended drawing and painting classes at the Salford School of Art, and continued to do so, infrequently, until 1925. His art school associations thus continue over a period of some twenty years.

1926–30
During this period he exhibited in open exhibitions in Manchester and at the Paris Salon. *An Accident* was bought by the City Art Gallery, Manchester. This was the first of his paintings to be acquired by a public art gallery. Commissioned to illustrate *A Cotswold Book* by Harold Timperley (Jonathan Cape, London 1931).

1932
His father died. First exhibited in the Manchester Academy of Fine Arts. First exhibited at the Royal Academy.

1934
Elected a member of the Royal Society of British Artists.

1936
Six of his paintings were shown in a mixed exhibition at the Arlington Gallery, London.

1938
Chance discovery by A. J. McNeill Reid who saw some of his paintings while visiting the framers, James Bourlet & Sons Ltd.

1939
First one-man exhibition at the Lefevre Gallery. Since then he has exhibited there on some thirteen occasions. *Dwellings, Orsdall Lane, Salford* purchased by the Tate Gallery. In October his mother died.

1941
An exhibition of the artist's work was presented at the City Museum and Art Gallery, Salford.

1943
One-man exhibition at the Bluecoat Chambers, Liverpool.

1945
Made Honorary M.A., University of Manchester.

1948
Elected a member of the London Group. Moves from Pendelbury, Salford, to The Elms, Stalybridge Road, Mottram-in-Longdendale, Cheshire. October: one-man exhibition at the Mid-day Studios, Manchester, where he exhibited regularly with the Manchester Group from 1946–1951.

1951
July–August: retrospective exhibition at the City Art Gallery, Salford.

1952
First exhibition at the Crane Gallery, Manchester. This gallery, under the direction of Mr Andras Kalman, was the first commercial gallery outside London to show Lowry's work. Further exhibitions were held there in 1955 and 1958. Now the Crane Kalman Gallery, London, it has shown his work on a number of occasions. Lowry is represented in the Collection of the Museum of Modern Art, New York.

1955
Made an Associate of the Royal Academy. An exhibition of his work held at the Wakefield City Art Gallery.

1959
June–July: retrospective exhibition at the City Art Gallery, Manchester. Exhibited, Robert Osborne Gallery, New York.

1960
April–May: exhibition of drawings and paintings at the Altrincham Art Gallery.

1961
Made Honorary LL.D., University of Manchester.

1962
Elected Royal Academician. September – October: retrospective exhibition at the Graves Art Gallery, Sheffield.

1964
In November, an exhibition in his honour was held at the Monks Hall Museum, Eccles. Twenty-five contemporary artists, including Henry Moore, Barbara Hepworth, Ben Nicholson, Duncan Grant and John Piper, took part. The Hallé Orchestra gave a special concert in Manchester to celebrate the occasion of his seventy-seventh birthday.

1965
June: received the Freedom of the City of Salford.

1966–7
Travelling retrospective exhibition organised by the Arts Council of Great Britain visited the Sunderland Art Gallery; the Whitworth Art Gallery, Manchester; the City Art Gallery, Bristol; and the Tate Gallery, London. On 10 July 1967 the G.P.O. issued a Lowry stamp reproducing a mill scene.

1971
Exhibition organised by the Northern Ireland Arts Council in Belfast.

1975
Made Hon. D.Lit by the University of Salford.

1976
On 23 February, the artist in his eighty-eighth year, died at Wood Hospital, Glossop.

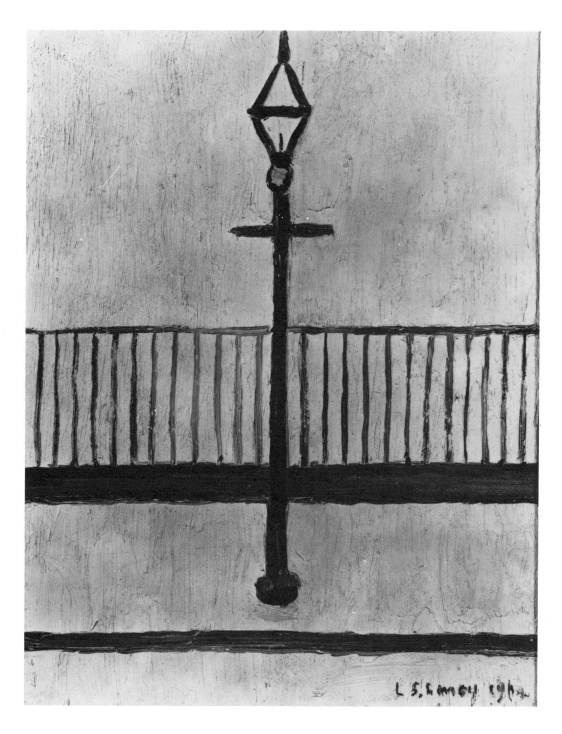

THE LAMP-POST

1964. Oil on board 27.9 × 22.8 cm. Collection: Lefevre Gallery, London.

INTRODUCTION

'I AM A SIMPLE MAN and I use simple materials: ivory black, vermilion, prussian blue, yellow ochre, flake white – and no medium. That's all I've ever used for my painting. I like oils. Watercolours I've used only occasionally. They don't really suit me; dry too quickly. They're not flexible enough. I like a medium you can work *into*, over a period of time. That's all there is to say, on how I work. I've done my best in my own way. I'm eighty-seven you know!'

There is a certain wry pride by L. S. Lowry in this last remark about his age, as though time, the great enemy, had somehow been cheated. And indeed the attitude was well justified, for no artist has more completely or more successfully, dictated the pace of his creative progress. From the single figure of a *Mill Worker* (11)* painted in 1912 to the bizarre *Interrogation* of 1962 (37) a span of some fifty years brims and teems with figures and factories, rivers and boats, landscapes and oceans, houses and bandstands, bustling football crowds and leisurely cricket matches.

In later years the single figure – often, I believe, the artist in one of his numerous disguises – has appeared more frequently. The message – perhaps that 'I alone remain, but emptied of my dreams.' To test this impression, I asked him, shortly before his death, how much he then painted. 'Oh, no, no – I can't do it anymore. When I look back at what I've done, I realise I've said it all. I couldn't do anything like that now! Why do they keep on and on some of them, when there's nothing more to be said? I'm only fit to scribble for children now. . . .' His avowal of retirement was not strictly true of course, because he did paint a little right until the end.

These simple and revealing remarks and those which open my Introduction were made to me by the artist on 7 February 1975, in the living room of his stone house at Mottram-in-Longdendale, Cheshire – a dark room haunted by the ghost of Rossetti,

*The figures in parentheses refer to the Plate numbers.

whose drawings lined the walls. It is fashionable today for artists to make statements: long-winded, arrogant, complex, mock-esoteric nonsense flows easily enough from the lips and pens of creative pygmies. The bigger the artist, the less, it seems, he has to say. Less manifestos and more work!

Picasso, who lived and painted longer than most, made only two important statements throughout his entire working life. One was to Marius de Zayas in 1923, and the other to Christian Zervos in 1935. Lowry and Picasso are hardly comparable, but two of Picasso's remarks illuminate Lowry's attitude towards his art, frequently expressed to me in different ways during conversations with the artist. 'When I paint,' Picasso stated in 1923 (Lowry was then aged thirty-six and rapidly developing his vision of the industrial scene), 'my object is to show what I have found and not what I am looking for . . .' In 1935 when Lowry was still unknown, Picasso wrote: 'The artist is a receptacle for emotions that come from all over the place; from the sky; from the earth; from a scrap of paper; from a passing shape; from a spider's web.'

I need use only three examples at this point to illustrate how clearly and crucially these concepts apply to the painting of Lowry. In this sense both Lowry and Picasso, however diverse their vision, are concerned with universals; with the common denominators of art. Lowry did not *seek* the opposing patterns of energy and repose which, respectively, permeate the feeling and structure of *Going to Work* (36) and *The Street Trader* (40). He found them. Nor did he seek the remarkable biographical implications of a simple painting, *The Lamp-Post*, reproduced at the beginning of this Introduction. Here was the object which reflected a very personal response; in itself inauspicious, the lamp-post in this painting becomes a vehicle of intense personal symbolism. It was not sought, it was found. It is also an emotional flashpoint.

My first book on the artist, *L. S. Lowry* ('Painters of Today'), was a slim study illustrated by only twenty examples of his painting, and with a text devoted mainly to anecdote. My second book *The Drawings of L. S. Lowry,* was, as its title suggests, concerned solely with his drawings. This present work, condensed from my third study,* covers a wide range of Lowry's work as a painter and will, I hope, help to illuminate further – in more depth, and obliquely – the art of a painter who is now securely established as a master of the eye of allusion, that richest vein of creative vision in which essence is distilled from subject and married to idea. It is a brand of visionary genius peculiar to the English masters. The French call it symbolism. The English see it as a strain of native eccentricity.

In this context, Blake would top the bill, and running somewhere beneath the level of his mighty visions for which the reconditioned 'body' of Michelangelo's art acts as host, flow the dreams of Fuseli, John Martin and, more latterly, Stanley Spencer, Edward Burra, Carel Weight and L. S. Lowry. Perhaps the difference between the Symbolist and the Eccentric vision is emphasised best by the marked affinities between the work of such painters as Redon and Moreau, and those artists bound into the philosophy of *Les Salons de la Rose Croix* (1892–1897), compared with the significant lack of any positive links between Spencer, Burra, Weight and Lowry. Certainly the

* *The Paintings of L. S. Lowry: Oils and Watercolours.* See Select Bibliography.

imaginings of Blake and Fuseli are superficially similar – they were contemporaries and friends – but only in some aspects of appearance, not in substance: there are absolutely no points of comparison between the religiosity of Blake and the eroticism of Fuseli, although they are aesthetically interchangeable.

The English eccentric painter is, then, distinguished by personal oddity, and no native artist is more curiously expressive of this than Lowry. Many of his titles even are quixotic and quizzical: *Bird Looking at Something; The Same Woman Coming Back; Young Man Trying to Convince his Mother about Something; Man Lying at Foot of Stairs.* Sarcasm often prevails: the most derelict of his tramps are usually referred to as 'gentlemen'; the most hideous of his old cronies are 'ladies'. He is a mocker of great individuality, great humour. Out on a limb, the artist is a 'loner', a fastidious observer who will suddenly seize a character from life and inflate it dramatically into a vision of loneliness, ugliness, or even horror. Eccentric too in his painterly interests – he admitted to me once that only two artists, Ford Madox Brown and Rossetti, held any real fascination for him – he is rather like the benign uncle who suddenly pulls faces and frightens the children. There is even something of the classical fairy tale element in his vision – that sharp, sometimes terrifying, contrast of good and evil, of malicious or at least, mischievous forces always at work alongside the safe and happy areas of life. But this is only in between times. For the rest of the time, the artist acts out in his canvases responses to life which reveal both his detachment from affairs, and his continual search for symbols and metaphors to express his personal isolation and detachment. In later years his canvases have become more sparsely populated. Single figures and many empty seascapes show his evolving obsession with the idea of loneliness, poignant yet magisterial.

I have discussed these crucial changes in the artist's later work in an article, 'Lowry and the Lonely Ones' published in the *Studio* in 1963. I quote the opening paragraph of this article:

During recent years, the work of L. S. Lowry has been growing steadily more rarified. The complicated patterns of figures in industrial settings have gradually been replaced by a diminishing number of characters, either set against the ghosts of former buildings, or, in the last year or two, presented in total isolation. Often, solitary figures materialise out of expanses of pure white, without any indication of spatial dimensions. Sometimes a tenuous breath of drawing – perhaps a stretch of railing – provides a key to their location in the world. But mostly these figures are set apart, or moving towards that utter loneliness of body and soul, which the painter has so often hinted to be, even in his densely populated canvases, the ultimate human state. Defeat in the struggles of life, physical deformity, ugliness, poverty, all these and kindred conditions actively accelerate the process of separation from one's fellows. The condition fascinates the artist, and during recent months he has been relating his philosophy of loneliness to the depiction of derelict characters; poor, crippled, misshapen. 'I am haunted by the loneliness of these characters made desolate by one set of circumstances or another. . . .'

But the real loneliness, of course, belongs to the artist, and among the most remarkable of these personal isolation statements is the painting of *The Lamp-Post*. Here is the ultimate image of detachment. Devoid of any obvious human connotations, it is

nevertheless 'man'. The railings are the limitations of the world, the object itself, a crucifixion. To understand the full depth of this statement, one must bear in mind the nature of Lowry's own life.

The facts are excruciatingly stark. Laurence Stephen Lowry was born in Manchester in 1887, the only son of R. S. Lowry, an estate agent, and Elizabeth Hobson. The family lived in Rusholme, a suburb of the city. On leaving Victoria Park School in Manchester, his parents sent him to one William Fitz, in Moss Side, where he was given private lessons in painting. Then in 1905 he entered the College of Art in Manchester where he was to remain for the next ten years. Here he learned to draw with considerable academic accomplishment, though with none of the flashy facility which distinguishes the work of such contemporaries as John or Brangwyn. Drawing from the antique was the basis of the approach to drawing, but when he began painting, it was the Impressionist style which the college taught. His teacher at this time was Adolphe Valette, himself well versed in the Impressionist method, and a tutor clearly much advanced for his period. It is a style which Lowry has used from time to time, both in his earlier work (30) and sometimes in his later painting. But Impressionism has never held more than a superficial interest for him.

His physical movements were few. In 1909, his parents moved to Pendlebury, in Salford, and in 1948, nine years after his mother's death (his father died in 1932), the artist moved to the bleak little house at Mottram-in-Longdendale, where he lived and worked, until the end, intensely alone. The rooms were small, dark, womb-like. His studio was a little back-room. No carpeting deadened the creak of the bare boards as one ascended the stairway to the upstairs rooms. Protected by the bosom of a loving family from any gross contact with the harsher realities of life, Lowry had always been free to come and go more or less as he pleased. Thus he always had ample opportunity to observe life, without ever needing to get too involved in the ebb and flow of situations. It is interesting to note that after leaving the Manchester College of Art in 1915 he attended drawing and painting classes at the Salford School of Art, on and off, until 1925, which means that he was an art student for the best part of twenty years. The fact is not without relevance since it explains his always studious, closely observed scrutiny of scenes, people, and situations.

His life-style was always simple in the extreme. He neither smoked nor drank (his favourite tipple was orange squash). He had never been abroad, never owned a motor-car, or a television set, and only towards the end – and for obvious reasons considering his age – possessed a telephone. But this deadly machine was strictly taboo except for an occasional outgoing call. The white circle of the disc under its celluloid cover carried no number which could be taken by the prying eye of an unscrupulous visitor. He had never, by his own admission, 'been in love', and in his guarded conversations with me on this delicate topic, I always took this to signify an admission of virginity. Beyond the love for his mother, who died when Lowry was fifty-two, there were only the unattainable phantoms of the Rossetti women who haunted his front parlour with their doleful sensuality.

It is understandable that a man who lived with, and directed all his affections towards his mother until her death at a mature point in his life, might find it difficult,

if not impossible, to establish a normal relationship with any other woman. Hence the compensatory (safe!) mother-lover-wife phantoms of Rossetti. The libido will not be denied its pound of flesh. This fact would also account for the artist's general withdrawal from the world, and his ever-increasing role as the lonely, isolated observer. And thus perhaps the crucifixion of *The Lamp-Post* – a self-immolatory *cri de coeur*.

The artist's acquaintances were legion, his friends few. To all he remained 'Mr Lowry', no matter how long you had known him; yet another indication of his insistence on isolation. His physical needs were minimal. Egg and chips, chops, sausages, tomato soup – these were his favourite foods. He was not interested in clothes, or travel, except, in later years, for long seasonal visits to stay at the Seaburn Hotel on the sea front at Sunderland. From there he made sorties to South Shields to draw and paint the ships in dock.

The sea had steadily emerged as a vital image in his painting. In later years, it appeared as an element in its own right. Earlier it had often figured in the artist's work, but merely as a backdrop for the activities of the people in the many beach scenes he has drawn and painted over the years, or simply as a receptacle for boats (29). Latterly, however, whether in calm (31) or choppy weather, it symbolised the character of the artist's life. The sea is mostly serene, sometimes a little rough, but never storm-tossed – he was too well insulated for that. Having lived with his parents for over half a century, he was, as I have already suggested, well protected against the ebb and flow of the harsher tides which most men have to face. The more ferocious storms of life have never crashed along his shores. Yet for all the security of this privileged position, Fate, with characteristic mischievousness, saw to it that the artist was not discovered until shortly before his mother's death. To his perpetual chagrin, she was never to enjoy the full measure of his success – she died in 1939, the year of his first important exhibition (at the Lefevre Gallery in London).

The circumstances of Lowry's discovery are well known. In 1938, Mr A. J. McNeill Reid, the senior partner of the Reid & Lefevre Gallery, London, happened to be visting James Bourlet, the framers, and saw a few of Lowry's paintings lying around. He was immediately struck by the intensely original quality of the pictures, made contact with the artist and within a year Lowry had been given his first, highly successful exhibition at Mr Reid's gallery. This was the major turning point in his life as a painter. It was also the point at which his real loneliness begins to take its final shape. With his mother's death, the artist began in earnest a withdrawal from those contacts with the world which mark the identity of Everyman. Not that Lowry had ever been a recluse; no one enjoyed good company more than he. His sense of humour and fun was superb. It is just that he refused to be 'touched' by life – by events or by people. He would remain 'self-contained'.

The precise point of Lowry's retreat is marked three years before his mother's death with the imaginary portrait, *Head of a Man with Red Eyes* (5). This, he told me, was painted under great emotional stress, and at a time when his mother was very ill. It is a remarkable summation of personal *angst*. From this point, Lowry became less interested in the personality of people. The *Portrait of Ann* (43) possesses the same implacability, the same remote and anguished stare as the *Head of a Man with Red Eyes*.

It is a symbol of his own apartness, not a portrait of a particular person but of an abstracted individual.

He is often, as in *The Cripples* (41), a mocker of suffering – his sense of irony is acute. That same malice of fate which denied his parents, and his mother especially, sight of his success, also shaped *The Cripples; all* cripples. They will not be spared in his canvases, his compassion will not ameliorate their lot. They will be seen for what they are; grotesque and comic objects, 'funny to look at', as Lowry observed to me. Indeed, we once made a strange forty-minute bus journey through the outskirts of Manchester, travelling on the top deck, to see how many cripples we could spot on a scheduled run. He had earlier expressed his intense interest in the ludicrous appearance of the cripple as an *object*, and had argued that there were a great many about in the city and its environs. I had countered by saying I didn't think cripples and deformed people were that common a sight. We took the bus trip so that he could prove his point, which, remarkably enough, he did. At no time on this journey was he interested in deformity as an element of human suffering, only as an appearance: comic, ugly and grotesque. The 'black humour', almost, of the surrealists.

Into this category falls an extraordinary portrait of a *Woman with a Beard,** a lady the artist saw while journeying by train from Cardiff to Paddington. The *Head of a Man with Red Eyes* describes his fury with the fates, his evolving sense of isolation, his blind frustration, his despairing loneliness, the black irony which drove him, not into reclusion by any means, but away from any close identification with the personality of human beings. Certainly he was never much interested in people as individuals, yet the portraits of his father and mother painted in 1910 (32, 33), and the tender water-colour of his mother painted a year earlier show him to be a portraitist of sensitivity and to have real feeling for the personality of his sitters. They are all deeply empathetic. The retiring self-portrait of 1928 also displays a simple regard for the humanity of the face. It is an exercise in objective observation which stems directly from the artist's years of patient and painstaking study at the Manchester College of Art. It is revealing to compare this relatively objective study with the *Head of a Man with Red Eyes,* in all but name a profoundly introspective self-portrait. This clearly illustrates my opening references to Lowry and the art of allusion. As the essence of Hyde was distilled from the subject of Jekyll and married to Stevenson's idea that evil is latent in all men, so the *Head of a Man with Red Eyes* marries the physical distillation of inward suffering to the ideas already discussed about the origins of this portrait. Indeed, in later years, all Lowry's portraits are in fact 'self-portraits'. All would stem from the same springs of introspective loneliness that brought the image of the *Head of a Man with Red Eyes* surging onto canvas.

In objective terms, Lowry grew, by subtle degrees, more hostile to the world. His early affection for the inhabitants of the industrial scene was gradually transformed into a mocking remoteness. Never having been much of a 'player', the artist increasingly assumed the role of 'referee'. He studied the game without ever taking part, watching with remorseless eye the running of the players, their gyrations and tumbles,

*Plate 69 in *The Paintings of L. S. Lowry.*

their stops and starts. Nothing could be less 'humanitarian' than his view of *The Cripples*. Almost every figure is an object of ridicule. The essence is the ugly, the grotesque, and the ridiculous aspect of man; the idea, the ludicrous isolation of man.

In aesthetic terms, Lowry never found his 'beauty' in man, the animal. In his foreword to the catalogue of a Lowry exhibition held at the Hamet Gallery in 1972, Maurice Collis quotes Lowry as saying: 'When I was young, I did not see the beauty of the Manchester streets. I used to go into the country painting landscapes and the like. Then one day I saw it. I was with a man in the city and he said, "Look, it is there." Suddenly I saw the beauty of the streets and crowds.' Yet it was not in the people as individuals that the artist was to find the beauty he had earlier discovered in nature (27), but rather in the crowds, in the masses of people, in the patterns and shapes and rhythms they made against the background of streets and buildings, mills and factories, with their tall, smoking stacks. In these things, he discovered the poetry of the industrial landscape. The beauty of his painting, which evolved as the industrial scene gradually took hold of his imagination – a hold that was not relaxed and is just as powerfully apparent in the purely imaginary townscapes of later years – is a marvellous distillation of essence and idea. The clean, square shapes of the mills and factories, with their domes and towers and pinnacles, symbolise the essence of the authority which govern-ed (the tense is in the past since Lowry's *zeitgeist* is essentially rooted in the twenties) the aesthetic patterns of organised labour. They tower like palaces behind and above the unending ballet of the scurrying workers, who were not then, as now, unhappy in their lot – or not consciously so. For there was work and there was recreation, and the artist saw in all these varying streams of human activity, of labour and play, the simple fact that man's destiny is *la danse de vie*.

The acceptance of this destiny of work and play was absolute at that time; the finer shades of industrial unrest, the days of union power and strikes, were still far off. The catalogue of man's activities was simple and abiding. This was the milieu from which Lowry's view of the working man emerged: he saw in these humble comings and goings neither the Germanic *danse macabre* nor the pallid, starving destiny of the dark, satanic mills. Poverty there was of course, but it was a fact of life, and there were compensations. In this setting Lowry saw man, the ant, labouring and enjoying him-self. He observed people in many situations: sometimes quarrelling; sometimes startled; now curious at the scene of an accident; now patiently waiting for the shop to open or papers to arrive – all living out their karma against the great buildings which seem to symbolise, even beyond the authority of management, the ultimate and divine authority of God. There is surely a parable here. An artist chooses his metaphors to express ideas that spring from depths of experience and awareness beyond the purely personal. He is an artist of sorely limited ability, after all, who operates only at the face value of a Munnings' horse's bum.

In his art, Lowry conceptualises not only reflections of personal loneliness, but also the wonder and the mystery of the creation in which man is set as an unwitting pawn – defenceless, stupified, and occasionally noble. Thus, beyond and through a view of the apartness and oddity of individual man, the artist creates at his greatest – and he is at times a very great artist – a view of humanity which *must* show man as a

mere ant in the totality of the universe. So he will move with the crowd, as in *Daisy Nook* (19), absorbed into its ebb and flow as a wave into the rhythm of the sea. His greatest paintings, those depicting crowds, are simple allegories of the life of man. In this respect he can, of course, be compared with Breughel. The comparison is not new, but it is a good one and repays close study. The Breughel peasant and the Lowry worker are not far apart, and anyway, it is not man that changes, only his disguises, his appearance. In the industrial scenes, the palaces of management are also the halls of heaven. Every mill and factory is also a mansion 'in my father's house'. They are not only the background for work or play but are also churches, mosques, synagogues, or cathedrals. These mysterious buildings, often brightly lit by empty windows, symbolise the unknown. What ultimate power dwells in these halls of heaven? Lowry ventures no answer. Like other great artists he only *poses* questions.

The theme of the factory and the crowd is one to which he regularly returned throughout his art. For many years past, he no longer needed to 'look'. He found his vision long ago, and his vocabulary of images – as Leo Solomon once suggested to me – was so firmly established in his soul that it had become a pure language of the heart. Perhaps one can best see the ultimate significance of Lowry's vision as expressing itself in two main forms: the single figure; and the crowd. And this, after all, is the essence of man's existence.

These deep soundings are the centrifugal sparks of a profound inner vision. Looked at inversely, they are the vortex of an awareness which accepts the fact that man, the individual, can enjoy no peace until the spark of his life is reunited with the infinite out of which it has been thrown to shine momentarily against the enveloping industrial darkness (23). In this sense, *Daisy Nook* is a perfect metaphor of the vortex of life reclaiming its elements; indeed, *Daisy Nook is* that vortex.

Another measure of the great artist is his ability to operate at much more parochial levels. Witness the fleeting sketches of Rodin, the erotic humour of Picasso, and, in its own unique way, the comic vision of Lowry. The artist often spoke to me of his affection for the art of Charlie Chaplin, and there seems little doubt that his own humour has been influenced at points by the film comic. His painting of *Father Going Home* (47) displays more than a touch of Chaplinesque influence.

While we are considering the subjects which have most interested the artist apart from the industrial scene, we might comment here on Lowry's sporting pictures. He talked with great authority of football and cricket, recalling with a flashing pleasure the names of the footballers and cricketers of his youth. Burgess and Meredith of Manchester City seemed to hold a special fascination for him and he could give you the names of most of the City football teams of his day. With what relish he talked of the giants of cricket – Lord Hawke, Ranji, Wilf Rhodes – the names flowed easily from his tongue, still to be savoured as he recollected their feats of skill with bat and ball.

Football crowds often appear in his painting, and there is one fascinating cricket picture. The story of this picture was told to me by Alick Leggat, a long standing friend of the artist and for many years Honorary Treasurer of the Lancashire County Cricket Club. The picture, now in two pieces,* was produced over a lengthy period

*Plates 65 and 66 in *The Paintings of L. S. Lowry.*

between 1964 and 1969, Mr Leggat having supplied the artist with details of the field positions. Lowry, however, was not satisfied with the result and promptly cut the picture in two. The lower and smaller section was partially repainted, and if, as I have done, one puts the two parts together again, making one picture, I think one can see quite clearly why the artist was not satisfied. Almost none of the figures in the lower section are actually looking at the players. They are turned towards the spectator and it appears that, when the artist got involved in this area, he became engrossed in problems of construction that had little, if any, relationship to the game being played in the upper part. On the reverse side of this portion of the painting is a pasted statement by the artist which reads: 'This picture of a *Crowd around a Cricket Sight Board* is the lower portion of a larger canvas measuring originally 30″ × 25″. Owing to the difficulty of reconciling the two portions, I decided to make two separate pictures. This is a smaller portion mounted on board and mahogany and I consider it one of my most successful crowd scenes. L. S. Lowry, 29 April 1970.'

A mistake often made in discussing the work of Lowry is concluding that he is primarily a painter of the industrial scene. If this book were only to be seen and read by those familiar with Lowry's work, the validity of the following view would not need to be emphasised. Since the book's purpose is to provide information for the emergent Lowry enthusiast, as well, I hope, as consolidating evidence for the securely entrenched 'man about Lowry', it is important to show in how many different areas the artist has worked, and with what consummate enthusiasm and skill. The picture, however, cannot be complete without reference to my earlier book on the painter's drawings, because this establishes the basic fact that Lowry's early training in the science of purely academic drawing is in fact the corner stone of his entire *oeuvre*. This indeed is the case with any other artist of great achievement, from Michelangelo to Picasso. An early, and thorough training in the formal science of drawing – anatomy and perspective – is essential if in later years the artist is to be able to produce those personal stylizations without which it would be impossible for him to fulfil his creative objectives. The creation of a personal language is the complement of a great vision. Academic drawing is the forge out of which this language is hammered, and beaten into shape.

 Lowry's stylizations are the result, not of any lack of formal knowledge, but of the product of years of careful and patient study. He is in fact an artist of the greatest sophistication. We have often discussed the drawing of great artists and were always agreed that the highest point of genius is knowing what to leave out. It is not so much what is stated that counts, but what is *not* stated. The omissions make the great drawing and, ultimately, the great conceptual image. The image and the style are reconstituted and, at last, unmistakably personal, the signs by which the work of the master can be instantly recognised. And although, as I have already said, Lowry never drew with the flashing sleight of hand of a Sargent, or a John, the absolute confidence and thoroughness of his early drawing from the antique and life, gave him an unassailable bastion of academic knowledge from which even the most expressionistic of his late imagery descends with magnificent authority.

Foremost among the subjects which precede the emergence of the industrial scene must be ranked the wonderful series of landscape paintings in pastel* which the artist produced between 1912 and 1920. These were based mainly on scenes at Lytham St Anne's and Fylde, and display a tenderness and an affection for nature which suggests that the artist could well have found his *métier* as a major painter of landscape. The influence of impressionism – or Adolphe Valette's version of it – can be clearly seen in the delicate pastel of Lytham (27) with its subtle nuances of colour. This vein of 'Manchester Impressionism' can be discerned in many other paintings from every period of the artist's work. Only in one respect do these paintings depart from common impressionist method: when the artist uses black, however sparingly and subtly, to help the mixing of his dark colours. Nevertheless, at its best, Lowry's impressionism is worthy of any European master of this idiom.

Even after the artist, it seemed, had become irrevocably drawn to the industrial scene, he frequently returned to the landscape theme. If not any longer for its own sake, then as a setting for one of the artist's favourite images – the cart. Sometimes conceived in a nebulous, impressionistic style, at other times in a clean, sharp manner, the cart, like the cab which also appears repeatedly, acts as a reminder of the running out of time along the lonely, barren roads of life. The cart, or cab, represents that place of maximum security – the womb.

Desolate landscapes, like the empty seascapes, also figure prominently in his work. Poems of the solitary. All in their varying ways are portraits of the life of the artist. The autobiographical element in Lowry's work is always very strong, and often only thinly veiled. But early on, at the roots of his art, are set a few powerful, immensely accomplished still-life paintings (7). Like jewels in a crown of thorns, they glitter with diamond highlights, the colours full and rich. These paintings, like the drawings from the antique and life reveal the astonishing ability of the artist as a draughtsman and painter, using his colours with a lush, brimming *matière* reminiscent of Courbet at his finest.

Lowry's feeling for paint itself is one of the features of his technical style which needs to be stressed. Often his pigment is used 'fat', the brush strokes speaking a language of their own, to be savoured as a quality additional to the subject, and forming the part of the consummate work of art that Clive Bell called *significant form*. This quality places Lowry well up in the hierarchy of those masters – for points of immediate comparison let us take Manet and J. D. Ferguson – who use the full, rich body of oil paint as a vehicle of substance and expression in its own right.

Looking at the early still-lives, or the portraits of his mother and father, there is, as yet, little indication of the coming storm, the sudden revelation of the crowds and the streets which were to explode from the artist's imagination between the years 1915 and 1920. However, as early as 1912, there is a strong hint of the coming apocalypse of grime in the pastel of a *Mill Worker* (11). This is perhaps the first recorded appearance of the mill and the factory in the artist's work. What Lowry was soon to

*A group of some thirty smaller landscapes executed in pencil and white chalk on a range of different coloured papers was also produced about this time, and is now in the collection of Mr Monty Bloom.

establish, certainly by the mid-1920s, was a convention that was thereafter to change hardly at all. This was his view of people. Like a costume designer, he dresses his characters for the roles they are to play. His slovenly, gangling men, in their ill-fitting clothes, with great clumping boots and hats – whether caps, bowlers or trilbys, these are always too large, flopping and jammed low over their ears – his women equally ill-attired in outsize clothes, shawls and clumsy shoes – all fit a view of humanity which is firmly rooted in the working-class ethos of the 'twenties.

Lowry paid little attention to the passing of sartorial time, or the vagaries of changing fashion. Only here and there in his women do we sometimes receive a grudging indication that the artist has noticed, with half an eye, that there *have* been changes in the style of the clothes worn by his characters. I once asked the artist about this fixation in time, the preservation of the fly of the twenties in the amber of his imagination. His answer was simple and perfectly logical. 'I was happiest in the twenties, and I don't see why I should take my leave of them! Not in my painting at any rate!'

No less significant than the crowded, impersonal industrial and beach scenes are the more simple genre subjects which observe man in small units, such as *The Family* (13). This is a subject often drawn and painted by the artist, and illustrates in particular the problem of man's inability to communicate. These grim subjects even pose the question – *is* there in fact anything to communicate?

Most human beings, of course, can and do establish the temporary illusion of 'togetherness', but Lowry has always known that man is an island with the sea of events crashing around his shores. Sometimes a tide rushes in to wet the feet, or, in flood, to rise perhaps knee or even waist high. But the recession is inevitable, leaving the debris of life strewn around: the island must ultimately exist alone, in its solitude. Lowry preferred to build his breakwaters high enough to keep out the more tempestuous tides of life, and these strange visions of man isolated in the bosom of his family, in doctor's waiting rooms, or in the act of courtship, symbolise this act of self-insulation in an acute and telling way.

But *is* one safe if the tides of life are held at bay? The answer of course lies in the loneliness of the artist himself. It is the price he has had to pay for his tenuous safety. Yet, through *his* loneliness and isolation, we are the better able to understand the predicament which bedevils us all: the problem of communication, and the illusion of rapport. The fact is that, in the last analysis, we are all islands, adrift in a sea densely populated with other drifting islands. With some of these, from time to time, we come into temporary collision, to exchange words or emotions, before moving on. The 'bumping' of islands can be best seen in moments of hot emotion – love or hate. One such moment is delightfully satirised in *A Fight* (15).

It is necessary to stress the loneliness of the artist if one is to understand the deepest springs of his art. In his book, *The Discovery of L. S. Lowry*, Maurice Collis reports Lowry as saying: 'Had I not been lonely, I should not have seen what I did. . . .' And of his people and his stylised figures in particular he stated quite categorically: 'They are symbols of my mood, they are myself. . . . Natural figures would have broken the spell of it, so I made them half unreal. . . . Had I drawn them as they are, it would

not have looked like a vision'. Nor, following from this line of argument is it generally realised that what often appears to be a straight, factual depiction of some particular place is, in part at least, imaginary. Lowry talked of his 'composite' townscapes. One of the most marvellous of these made-up, composite townscapes is the magnificently grand *Industrial Landscape** in the Tate Gallery. It is really a 'dreamscape', combining in one superb composition all those elements of the industrial scene which have haunted the artist's imagination since he first beheld its grimy, smokey glory. They are all there: the tall chimneys, the mills and factories, the churches and bridges, the long lines of working-class houses, and that most compelling of all the images that ever held his mind in thrall – the Stockport Viaduct. It appears in this painting, quite out of any actual topographical context, high up on the left-hand side of the painting, a distant vision, complete with train. 'It often appears in my pictures,' the artist once told me. 'As I make them up, I suddenly *know* I must bring in the Stockport Viaduct. . . . I love it . . . it is a part of my life, my dream.'

There are few people in this commanding picture. It belongs rather to the buildings, the smoke – and the vision of the Stockport Viaduct. It is a perfect example of Lowry's composite picture making. One of those paintings that have 'grown' as the vision gradually flooded the artist's imagination, holding him, as now it does the spectator, spellbound. As it stands at Stockport, the Viaduct is set relatively low in the townscape, but its grandeur is unmistakable and unforgettable. By its lofty elevation in the painting, the artist has heightened its majesty, and its air of mystery, endowing it with a quality of the unreal – part fact, part fantasy. We sense its structural strength, and its complementary delicacy, and we hear, as if with the artist's own inner ear, the long, distant scream of the train as it races across the stone trellis. It is the lonely, desolate cry of the heart.

Lowry's 'atmosphere' – the actual quality and character of the air breathed by his characters, acrid and corroded with the fumes of industry – is an element the artist often used to create the mood of his townscapes (22). Viscid and dark, yellowing and leaden, this is the very stuff of the bronchial gloom that pervades so many of his industrial scenes. That he has, in so many of his paintings, been able to re-create in the most imaginative way, this distinctive atmosphere is all the more remarkable since the basis of Lowry's painting is, and always has been, *white,* the masses of flake white that he manipulates with such skill and imagination. But the artist always insisted that his paintings would never read as he wished them to, until sufficient time had elapsed for the white in his painting to 'go down', as he put it. 'Give it time to yellow – to darken – to *discolour* – then you will see what I mean!' And this is true. Look at the street scenes of 1928 (24) and 1935 (22): the grime has besmirched the very soul of these paintings. It *is* the canvas.

It may seem curious that an artist of such scenes should base his palette on white, until one realises that there is no other way, no other technical direction by which the painter could arrive at precisely the kind of discoloration, of 'pollution', which he requires. Only white, given time, will 'go down', and change its appearance exactly

*Plate 124 in *The Paintings of L. S. Lowry.*

as the artist wishes. Lowry told how in 1924 he covered a board with six coatings of flake white, let it dry, and then stored it away for six or seven years. At the end of this period the white, unlike the pure, dead white of a newly prepared surface, had matured into a marvellous, subtle creamy yellow and pale grey. It had reached the threshold of the amber gloom.

Lowry's predominant use of white has led many critics to argue that he is not a colourist. Nothing could be less true. Those who level this criticism have neither thought about, nor *looked* at his painting. Because his palette is so strictly limited, he has of necessity to *make* colours rather than use them in greater or more obvious numbers straight from the tube. This inevitably leads both to simplicity and to much greater subtlety as a colourist; great and more closely knit harmonies follow quite naturally. There is certainly no lack of 'colour' in a painting like *Daisy Nook,* in fact, the reds and blues are marvellously bright, singing colours.

What binds the whole colour conception is the underlying use of black which, mixed with his prussian blue, vermilion, yellow ochre, and white, imparts a unifying quality to the whole scheme. And with what exquisite delicacy does the painter break his pure white into the softest shades and nuances of pink, buff, salmon, tangerines, pearly greys, pale drifting greens, and gentle lapis lazulis. Look at the fields and hills in the background of *Daisy Nook,* or the *Seascape with Sailing Boats* (29). The polarities of black and white subtly admixed with only three colours are sufficient, in his hands, to produce an orchestration of colour resonances which can range from a *fortissimo* of brightness, to a *diminuendo* of infinite softness.

These examples surely place the artist among the most brilliantly subtle of modern European colourists, although, under mistaken critical pressures, we have come to think of 'colour' in painting as that brash lineage of undiluted primary strength which descends from Fauvism and Expressionism to flood the canvases of the second-rate. The validity of Fauvism and Expressionism, and the unrestrained use of primary colour in relation to their respective philosophies was short-lived. The liberation of colour and emotion, which were the legitimate objectives of these important, pioneering movements, were inevitably debased by adventurers like Matthew Smith, or the late trivia of Raoul Dufy. One of the very few European artists to add creatively to the heritage of the Fauvist and Expressionist tradition, was the Scottish master, J. D. Ferguson. Had either he or Lowry been French instead of British their international reputations would have stood as high as any. I link their names here simply because they are, in my view, the two most significant painters these islands have produced this century: Ferguson because he extended, revitalised and redirected a tradition; Lowry because he created an allegory of man, in its way, as unique as that of Hogarth.

Lowry has used water-colour only occasionally. He had no great relish for the medium, although he can extract from its fleeting potential a deftness of touch and a shimmering translucency of colour which lends itself especially to beach scenes and seascapes (28). Pastel, the artist used early in his career, as I have already noted. Neither medium has exerted any marked or lasting influence on his work, although the use of pastel was, I believe, a vital step in the direction of oil painting as his ultimate medium. More controllable than water-colour, it may well have persuaded the artist that he

needed a colour medium that was not definitive at a stroke.

Although during the sixties, Lowry began to move away from the complex patterns of people and townscapes for which he is most popularly celebrated, it is in this intense and intentional formality of composition that his greatness lies. His masterpieces, I think, were produced in the quarter of a century between 1924 and 1949. All the key, tightly constructed, 'architectural' masterpieces of his *oeuvre* fall into this period, although he frequently returns to more loosely constructed and freely painted versions of the crowd and townscape theme later in his work. And if we consider for a moment the question of Lowry's 'composition', I think we must see him at his greatest *as* an architect. His pictures have the strong, firm, securely interlocking qualities of architecture. Nothing is superfluous, everything has its place and its purpose in the scheme of construction. Everything balances, though not in any dull, symmetrical sense. The whole edifice is firm, solid, like a well-constructed building.

Lowry is, then, at his greatest, an architectural painter. Compare *Daisy Nook* with Uccello's *Rout of San Romano* in the National Gallery. (Structurally, one can often compare Lowry's composition with that of the more architectural of the Italian masters, notably Piero dello Francesca.) Whatever incidental activities are taking place in a painting, however amusing the antics of the characters who wander around, all these are subservient to the painter's firm intention to ensure that the eye returns again and again, to whatever focal point of interest he considers to be paramount. In *Daisy Nook,* however much our interest wanders through the labyrinth, the eye will always and inevitably be compelled towards the sign which reads 'Silcock Bros. Thriller'.

It is the measure of great, architectural composition – composition in the classic mould – that the eye always finds a point of ultimate reference: a core of stillness, or of stimulation, which exists at the heart of the construction, and beyond all the impedimenta of incidental detail. Lowry, in his greatest works, never fails to provide this point, either of maximum repose, or, as in the case of *The Cripples,* of maximum excitement. Where else does the eye, or the interest of the spectator find its point of total absorption except in the central, crutched figure? One can trace the subtlety of this composition through the various elements; all of these are of interest in their own right, yet are placed with such skill that the spectator's eye is always destined to find the point of maximum stimulation. Consider the two dogs and their relationship to the scheme of this painting. The dog on the right is more conventionally constructed, the line of its body leads through the leg of the man to his head and that of his companion, and so to the central figure. The dog on the left *appears* to be leading the viewer *out* of the picture, but in fact its ears lead through the strange, stick-like contraption which supports the one-legged figure, upwards to his gaze, the line of which ensures the return of interest to the main point of focus. But this is a game which the reader can indulge as he wishes, and in relation to many other paintings.

Lowry's movement away from the complex compositions of his earlier years led him increasingly to the use of single figures, often set in a sea of whiteness. They move silently as in a lonely figure of a man in a bowler and two views of a young girl with a fantastic mane of hair, both reproduced in *The Paintings of L. S. Lowry: Oils and*

Watercolours. The latter is an idea that Lowry first developed in 1960. In my book in the 'Painters of Today' series, I reproduce a picture which combines the front and the back view of a young woman simultaneously moving forward, and away from the spectator again in total whiteness. When I first saw the remarkable painting in the artist's studio it had no title. Under pressure, since I wanted to use the painting in the book then in preparation, I asked for a title. After a few moments of deep reflection, the artist's face suddenly cracked into a broad smile. 'Let's call it the same woman coming back!' he suggested with twinkling humour.

This kind of cantankerous, eccentric whimsey is common throughout the whole of Lowry's art. His highlighting of the strange and ridiculous characterises the artist's break with the ordinary, the average view. In the 'forties he painted *An Old Lady* and *The Contraption.** Both conceptions take a solitary figure, and – as in the case of many other late, single-figure studies – use it as the basis for a process of relentless satire. Ugliness and misfortune are superbly mocked. It is this kind of caricature which links Lowry to the mainstream of English satirical art, and why I have drawn a comparison between his work and that of Hogarth. The crucial difference between the two is, of course, that Hogarth's caricature seeks to establish a *moralising* allegory of man and his destiny, whereas Lowry's satire, like that of Rowlandson, is totally unconcerned with the moral welfare of man. *Homo sapiens* is seen as a creature of loneliness and absurdity whose existence is punctuated by alternating periods of work and play: the mill and the football match. Sometimes this sense of loneliness and isolation is further intensified by reversing the conception of a picture and putting the figures into a negative state, like a photographic film. The effect is ghostly – a subtle and disturbing ploy.†

As Lowry had moved more frequently in later years to the single figure, or groups of a few figures, his style had grown freer, his brushwork looser. Clearly, at his age, this had become a more expedient method of working. Nevertheless, one must note that his looseness of style and brushwork has often run a parallel course with his more tightly painted pictures. In earlier paintings, the stream of free technique can be observed in those 'Impressionist' pictures like the *Whit Week Procession at Swinton* which of necessity call for an indeterminate style of treatment.

Lowry's greatness is reflected in many directions. There is, first and foremost, his creation of an allegory of man, and secondly the breadth and range of interest expressed in his diverse subject matter. Consider, for example, one group I have not even mentioned so far – the paintings of the Manchester blitz. Altogether the range of his interests as a painter is extremely wide, and entirely belies the idea that he is an artist of limited view. But on this matter, the illustrations chosen for this book will have more to say than any words of mine or anyone else.

How did Lowry feel, looking back across a seventy-year vista of painting, remembering that his genius went unrecognised for many years until it was discovered, by chance, only late in life? How many painters could have endured the years of neglect suffered by the artist, especially in his own city; for Manchester itself was almost completely

*Plates 83 and 87, respectively, in *The Paintings of L. S. Lowry.*
†cf. *The Haunt*, Plate 94, in *The Paintings of L. S. Lowry.*

unresponsive to his art until his reputation had become established. Long before the age of fifty-two, Mark Gertler had committed suicide for want of recognition. Lowry, fortunately, was made of sterner stuff, and enjoyed a long spell of fame and fortune since that day in 1938 when Alex Reid, confronted with a vision of genius, was discerning enough to see it for what it was and promote it. Asked on one occasion for his reaction to the news that a painting that he had sold years before for a few pounds had made many thousands of pounds in one of the London sale-rooms, Lowry replied with a remark that Degas made in similar circumstances: 'Like a winning race-horse feels when he sees the jockey presented with the gold cup!'

There is perhaps one key that will, at once, open the doors of the artist's personality and the meaning of his art. Strangely, it is contained in Lowry's dislike for Rembrandt, but then Lowry was a strange artist, and an even stranger person. His passions ranged from the goitred, pop-eyed sirens of Rossetti to the monstrous, scrupulous and terrifying pencil drawing of *The Plague of Snakes* by Ford Madox Brown which hung menacingly in a darkened corner of his front room at Mottram. His distaste for Rembrandt was expressed to me over a period in two separate, sharply defined and brilliantly succinct areas of criticism.

Some years ago when we were discussing the work of other painters – Lowry was of course one of those very rare artists who were totally uninfluenced by the work of other painters, though he was not without a very keen interest in other men's work – I asked him about Rembrandt. We had been covering the field of painting in precisely the way we often chatted about cricket. *Were* Hobbs and Sutcliffe actually a better opening pair than Woodfull and Ponsford? How fast *was* J. M. Gregory? What about Grimmett then? I remember he had just expressed a passion for Lucien Freud. On the question of Rembrandt he had no doubts. 'I don't like him – in fact I detest him – he's too life-like!' On my last visit to the artist, we again considered the question of Rembrandt. His view had deepened 'Oh, no! – he's too matter of fact – no poetry . . .' Of course, Rembrandt, by the very nature of his passionate interest in the personality of his sitters, by his unwavering involvement with men – as individual rather than symbol or cipher – *is* too life-like. For Lowry's philosophy at any rate.

Rembrandt saw literally; his mournful rabbis and crabbed old women exist in their own right – not as extensions of the artist's personality, or as mirrors reflecting his personal *angst*. They are the literal reflections of compassion. Their suffering was not Rembrandt's but their own. The art of Rembrandt is, in fact, too like life, too lacking in vision or allegory. As for the argument that Rembrandt lacks poetry, this I think is also true. There is *schmaltz*, there are tears, there is a sticky, cloying acceptance of the literal tragedy of man. There is the pity of old men and women worn out by life's struggles, backs bowed, hands crippled with age. This feeling for people is the antithesis of Lowry's view, where they are seen as symbols rather than personalities, metaphors even, certainly nothing less.

Rembrandt is, undoubtedly, one of the least poetic of painters. He does not use the conceptual poetry of masters like Breughel or Jan Steen, Lautrec or Van Gogh. Each of these painters, like Lowry, have used the image of man, not as a mundane symbol of the actuality of life, but as a vehicle for an allegory born out of the eye of

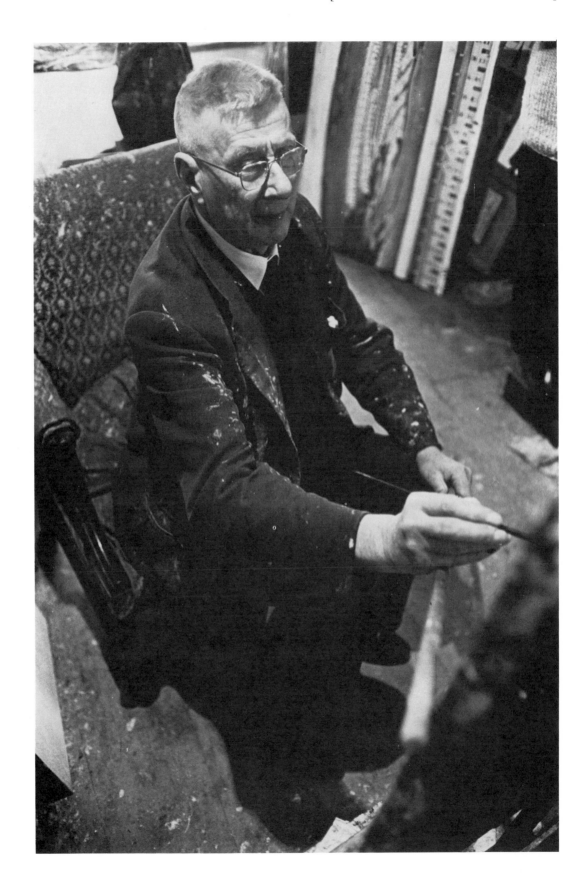

allusion, and to which, inevitably, poetry makes its contribution. In all great works of art this poetic element is present, whether it takes the epic form of the generation of English war artists, C. R. W. Nevison, William Roberts, Wyndham Lewis and Paul Nash – to bring the issue closer to hand – or Lowry's own discreet poetry of atmosphere and space; for it is these two elements which hold his dream.

His painting has the substance of what Sir Herbert Read once described as 'the poetry of the English Industrial Landscape'. Life is not art, but art *can* be life. It is the nature of L. S. Lowry's genius that he found, in his art, a perfect mirror for his vision of the destiny of man.

MERVYN LEVY
London, 1976

SELECT BIBLIOGRAPHY

COLLIS, MAURICE. *The Discovery of L. S. Lowry.* Alex Reid & Lefevre Limited, London 1951.

LEVY, MERVYN. *L. S. Lowry.* 'Painters of Today' series. Studio Books, London 1961.
The Drawings of L. S. Lowry. Cory, Adams & Mackay, London 1963, and Jupiter Books, London 1973.
'Lowry and the Lonely Ones'. *Studio*, March 1963, London.
The Paintings of L. S. Lowry: Oils and Watercolours. Jupiter Books, London 1975.

MULLINS, EDWIN. Introduction to *L. S. Lowry: Catalogue of the Retrospective Exhibition.* Tate Gallery, London 1966.

THE COLOUR PLATES

While the black and white illustrations which follow this colour section have been loosely grouped 'by flavour,' the colour plates exist in their own right and are left to speak as they wish irrespective of time, place, subject or any controlling conception of the present writer's.

I

SELF-PORTRAIT

1925. Oil on canvas 57.2 × 47 cm. Collection: City of Salford Art Gallery.

The artist in his thirty-eighth year, at a time when he was utterly alone and unrecognised, and five years before the first example of his work, *An Accident* (129), was purchased by the Manchester Corporation.

When I suggested to L. S. Lowry that I would like to include this canvas in my earlier volume he was less than happy. 'Oh! look at it now! See—the colours have gone; and surely, no one wants to see what the poor old fellow looked like all that long time ago?' I assured him that a great many people would be interested, and that his modesty was quite unjustified.

The sheer, Lancastrian doggedness that kept him plodding away through the long, lean years is clearly evinced in this portrait, in the big, determined nose and the quiet stubbornness of feature. It also offers proof of the artist's hatred of change: he still wears a cap similar to that in which he presented himself fifty years ago.

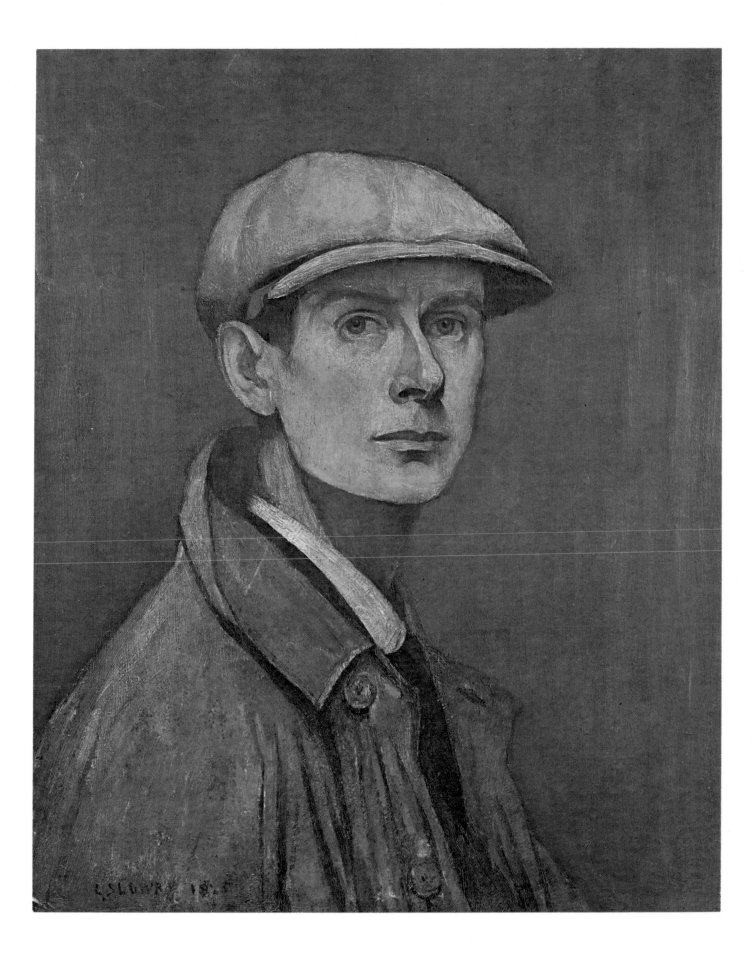

2

OUR TOWN

1941. *Oil on canvas 45.7 × 61 cm. Collection: City of Rochdale Art Gallery.*

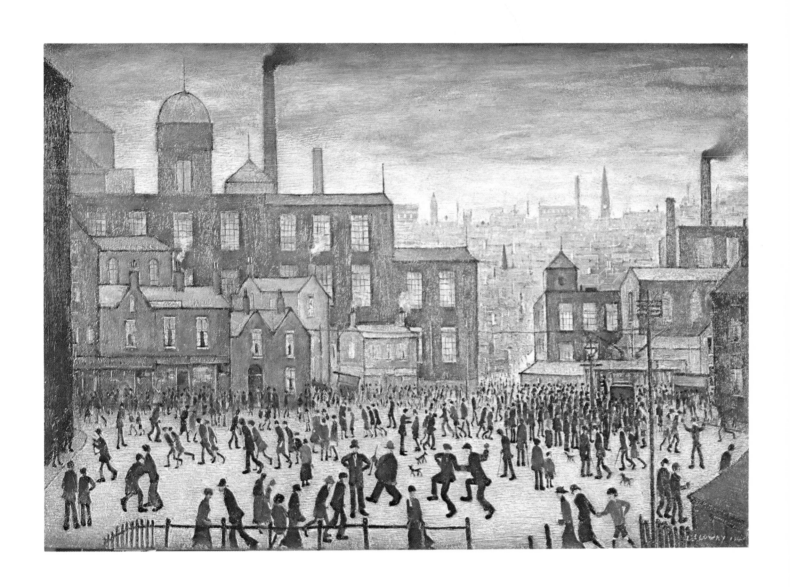

3

THE HOUSE ON THE MOOR

1950. Oil on canvas 50.8 × 61 cm. Collection: City of Salford Art Gallery.

The solitary house, a recurring image from the Lowry mythos. Compare this with the final plate in the present work.

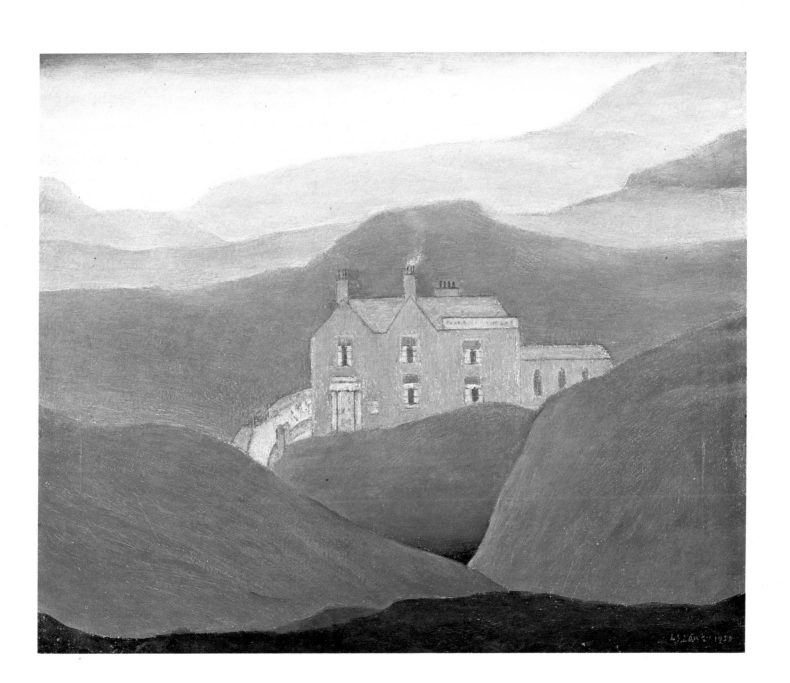

4

PEEL PARK, SALFORD

1927. Oil on board 35.6 × 50.8 cm. Collection: City of Salford Art Gallery.

A favourite subject of the artist's. The view is from the steps of the Royal Technical College, and the building on the left is the Public Library.

Several drawings of Peel Park from the same period are reproduced in the present writer's *The Drawings of L. S. Lowry*, Plates 15, 31, 41 and 46.

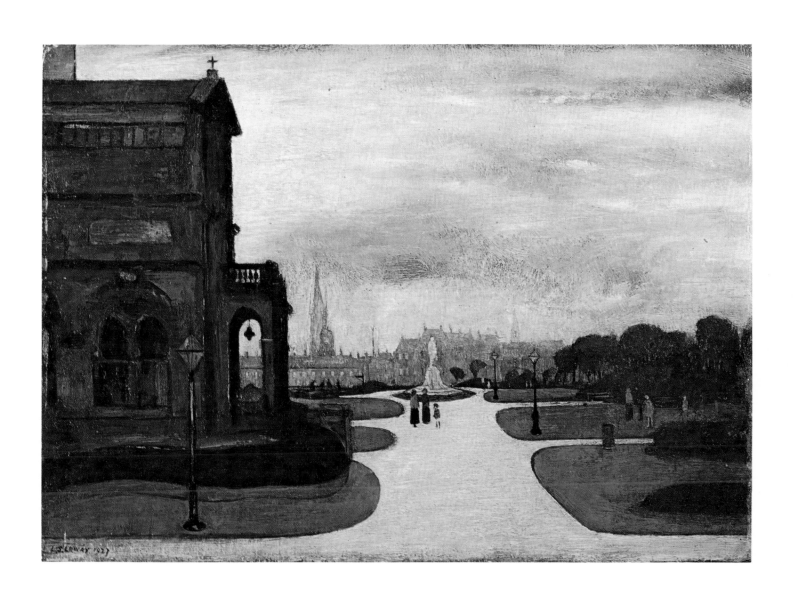

5

HEAD OF A MAN WITH RED EYES

1936. Oil on canvas 50.8 × 40.6 cm. Collection: City of Salford Art Gallery.

An imaginary portrait painted, so the artist told me, under considerable emotional stress, at a time when he was greatly perturbed by his mother's illness. 'It was just a way of letting off steam I suppose,' he explained.

Once again we are transfixed with an image of great loneliness; of loneliness intensified by suffering. Yet there is no bitterness, only a sharp cry of frustration.

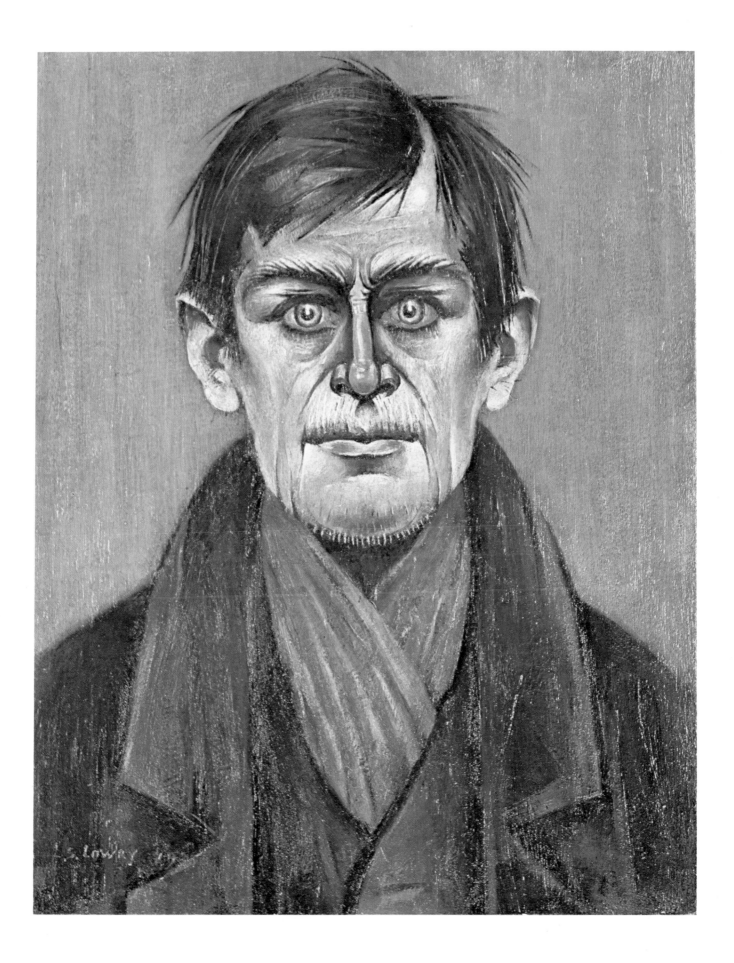

6

THE BEDROOM

1940. *Oil on canvas 35.6 × 50.8 cm. Collection: City of Salford Art Gallery.*

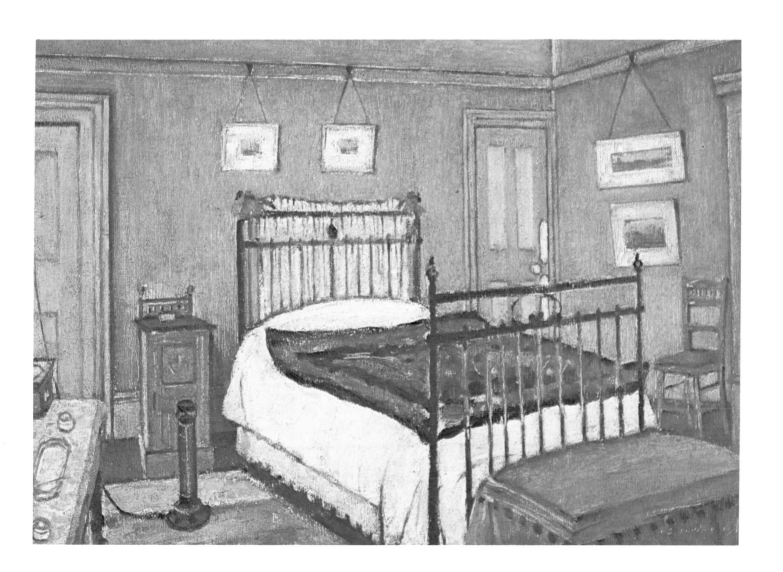

7

1906. Oil on board 24.2 × 34.3 cm. Private collection.

In the roots of L. S. Lowry's art are set a few immensely powerful still-life paintings. This majestic and formal oil reveals the full abilities of the artist using his colours with consumate skill.

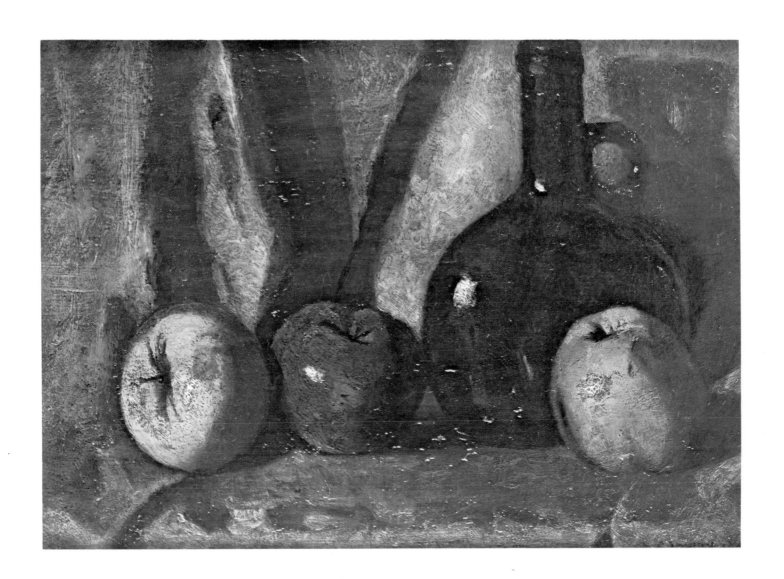

8

HORSE AND CART

No date. *Oil on board 25.4 × 12.8 cm. Collection: H. B. Maitland Esq.*

Though impressionism never held more than a superficial interest for Lowry, his ventures into the style proved accomplished and notable.

9

THE FIRE

1930–42. *Oil on board 41.9 × 31.8 cm. Collection: Crane Kalman Gallery, London.*

10

THE ARTIST'S MOTHER

1909. *Watercolour on paper 34.3 × 26.7 cm. Collection of the Artist.*

II

MILL WORKER

1912. *Pastel on paper 38.1 × 22.8 cm. Private collection.*

The first appearance of the mill and factory in the artist's work.

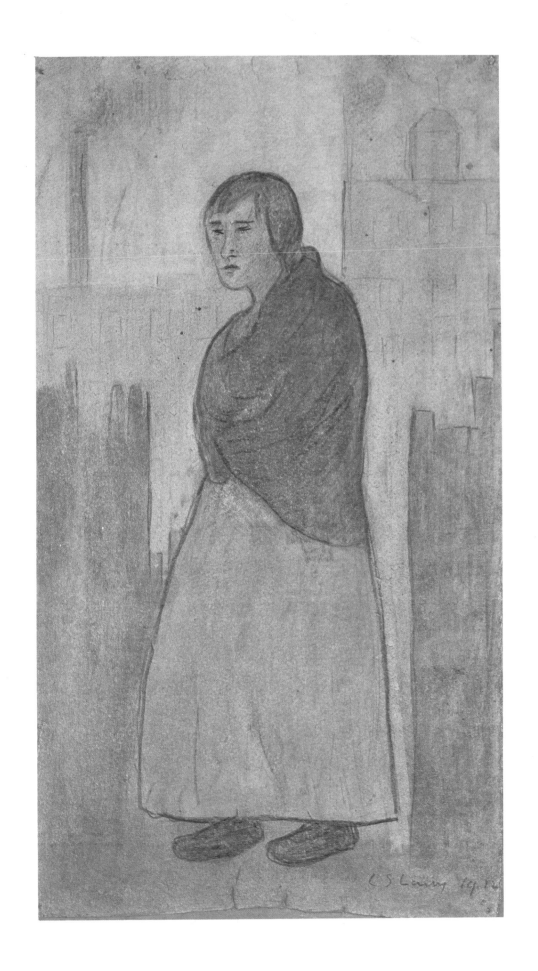

12

THE QUESTION

1953. Oil on board 24.2 × 15.9 cm. Private collection.

A subtle, masterly use of bold colour playfully applied.

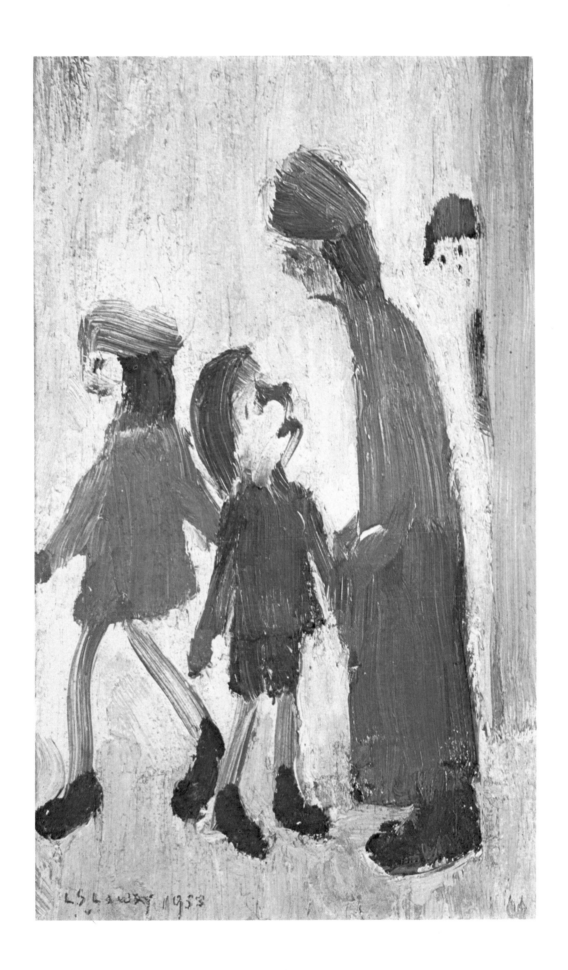

13

1936. Oil on canvas 44.5 × 36.8 cm. Private collection.

A composite picture based upon general observation. Plate 16 in *The Drawings of L. S. Lowry*, a pencil sketch dating from some sixteen years earlier, was the original for this present oil.

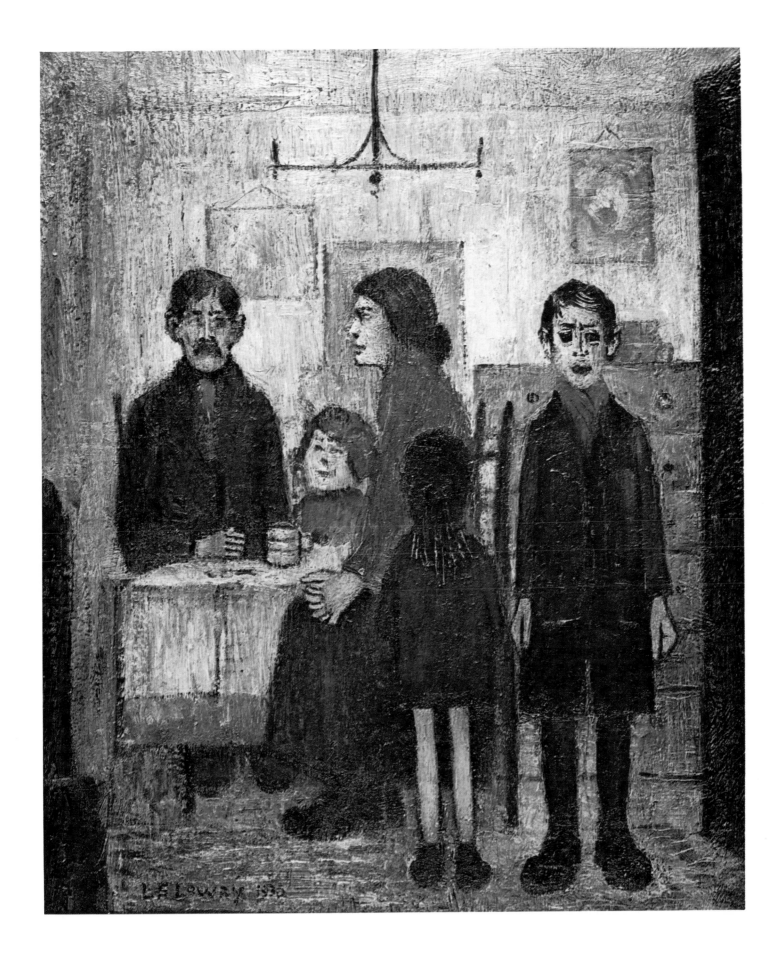

14

A DOCTOR'S WAITING ROOM

c.1920. Oil on board 27.9 × 40.6 cm. Collection: City of Salford Art Gallery.

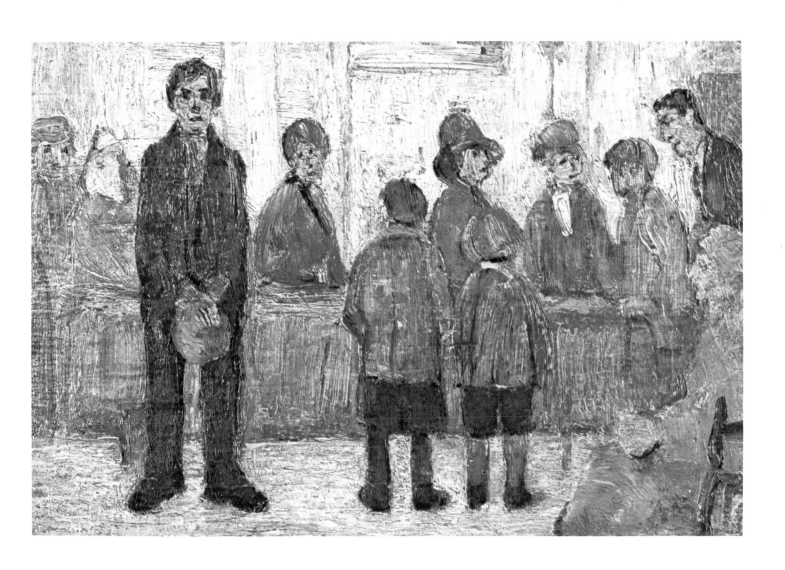

15

A FIGHT

1935. Oil on canvas 52.1 × 39.4 cm. Collection: City of Salford Art Gallery.

Laurence Lowry as the Charlie Chaplin of painting. The big-booted, bowler-hatted men and the shapeless women symbolise, as did the great comedian in so many of his early characterizations, the laughable pathos of the human predicament.

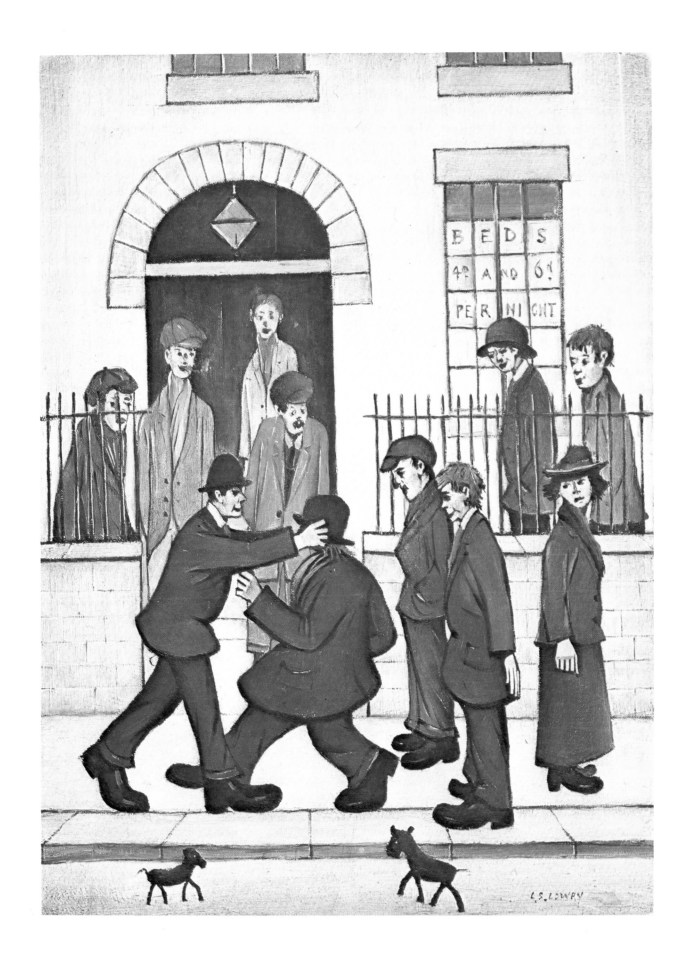

16

GROUP OF FIGURES

1959. *Water-colour on paper 34.9 × 24.2 cm. Collection: City of Salford Art Gallery.*

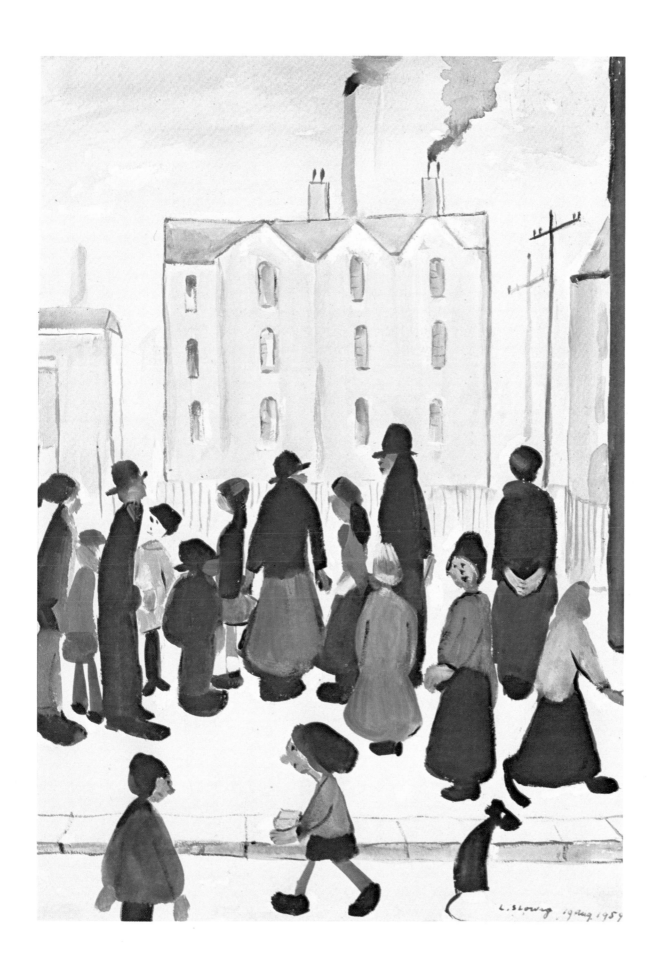

17

AN ORGAN GRINDER

1934. *Oil on canvas 53.3 × 39.4 cm. Collection: City of Manchester Art Gallery.*

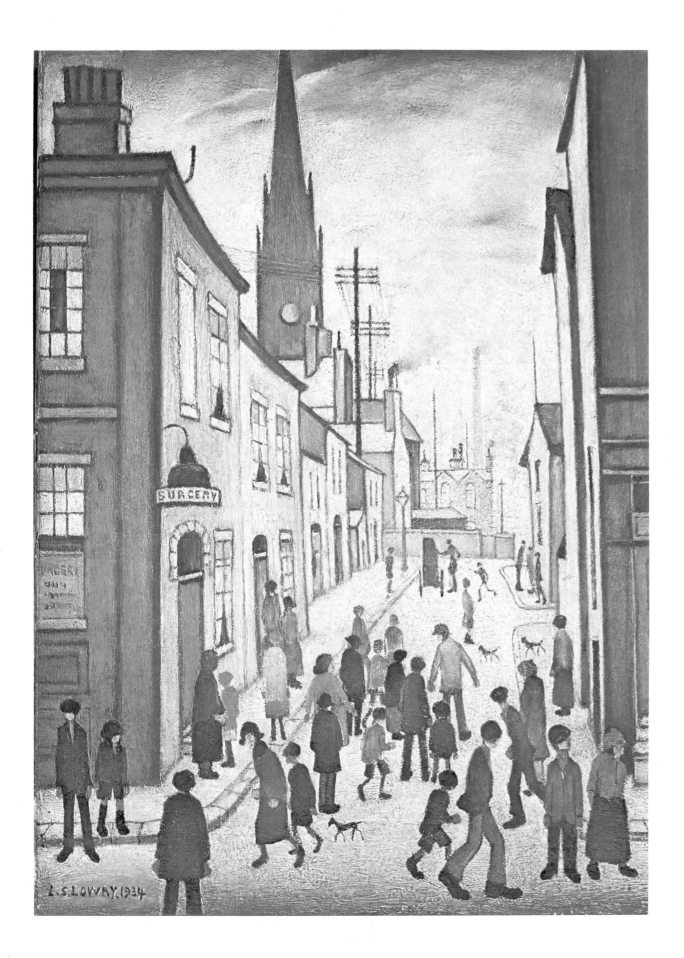

18

INDUSTRIAL SCENE

1967. Oil on canvas. 30.5 × 25.4 cm. Collection: Leo Solomon Esq.

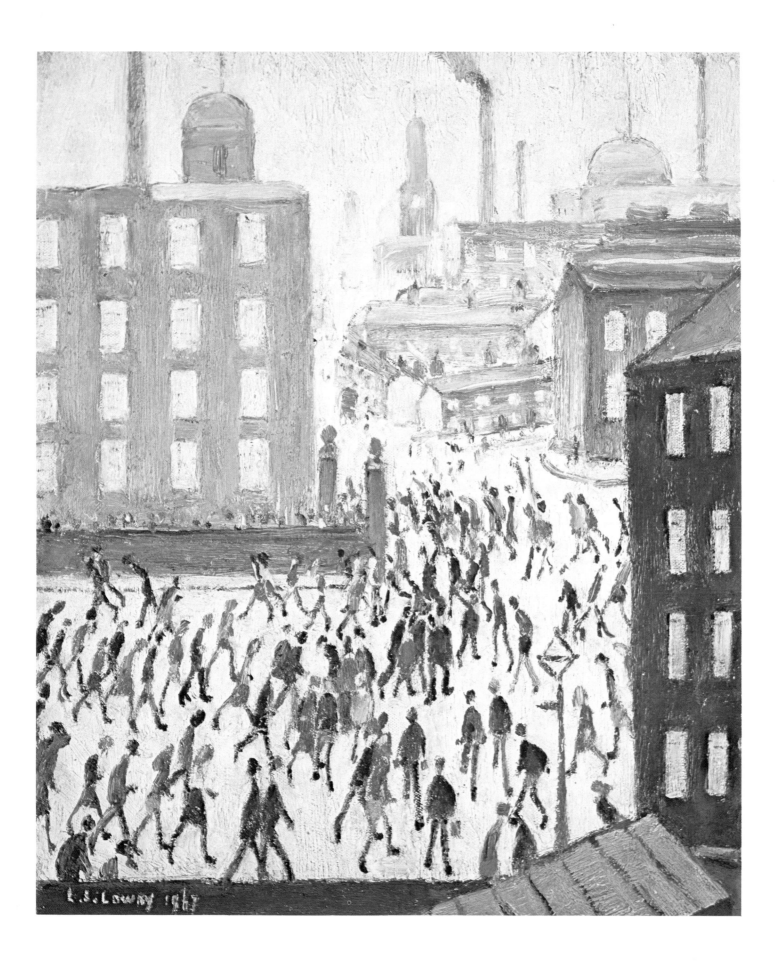

19

GOOD FRIDAY, DAISY NOOK

1946. Oil on canvas 76.2 × 101.6 cm. Private collection.

Albert Camus has written: 'I know from my own experience, that a man's life-work is nothing but a long journey to find again, by all the detours of art, the two or three powerful images upon which his whole being opened for the first time'. And this is precisely what Lowry has done, he has found that clear and potent image of childhood. No where more so than in *Daisy Nook*, which takes its name from a locale between Droylsden and Failsworth, near Manchester, where an annual fair is held on Good Friday.

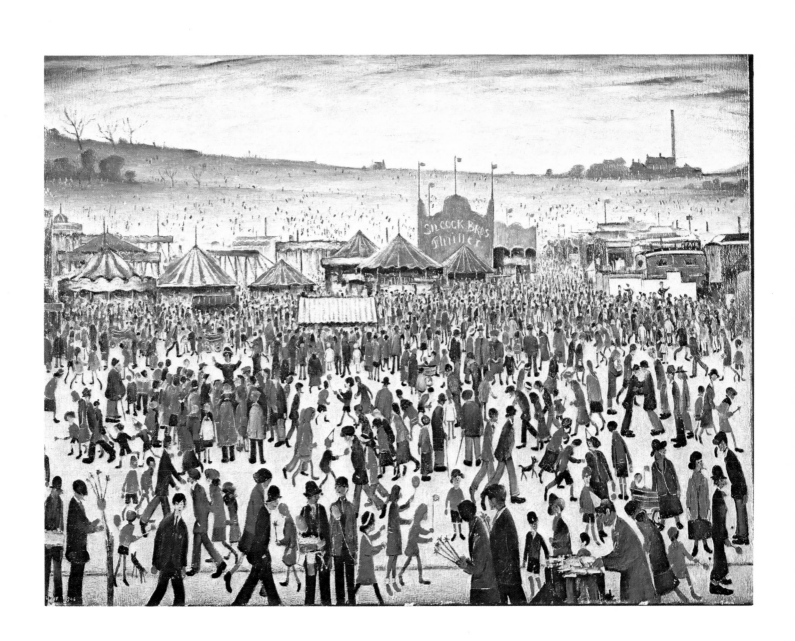

20

INDUSTRIAL LANDSCAPE

1931. *Oil on canvas 50.8 × 61 cm. Private collection.*

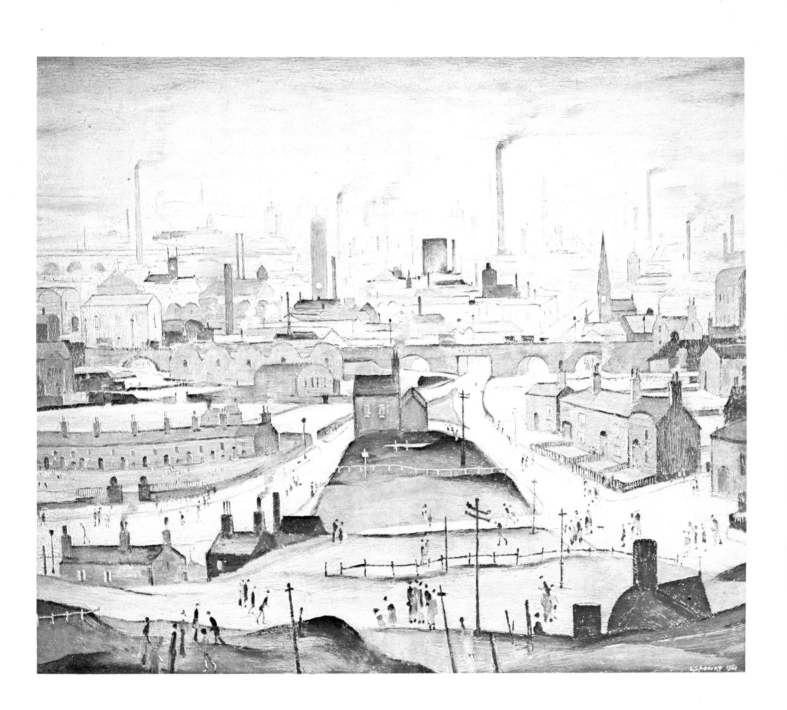

21

STREET SCENE IN SNOW

1941. *Oil on panel 36.8 × 61 cm. Collection: H. B. Maitland Esq.*

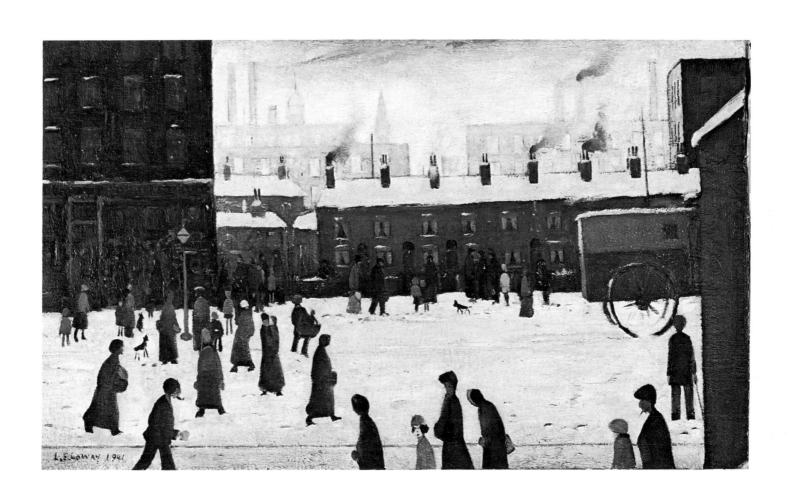

22

STREET SCENE

1935. Oil on canvas 40.6 × 30.5 cm. Private collection.

23

LANDSCAPE IN WIGAN

1925. *Oil on canvas 34.3 × 34.3 cm. Collection: Dr A. W. Laing.*

An industrial landscape based on a view of an iron works, now demolished, situated near Wigan between Hindley and Ince.

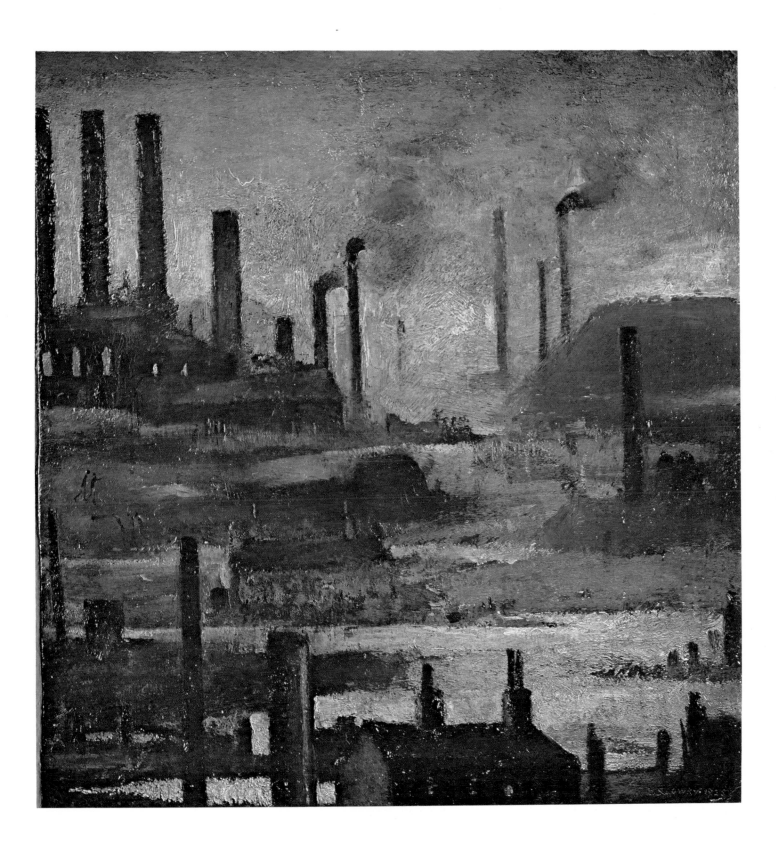

24

SALFORD STREET SCENE

1928. *Oil on board 41.3 × 30.5 cm. Private collection.*

An early affection for the inhabitants of the industrial scene is here very much in evidence. Compare this with the remoteness displayed in Plate 78, painted forty-four years later.

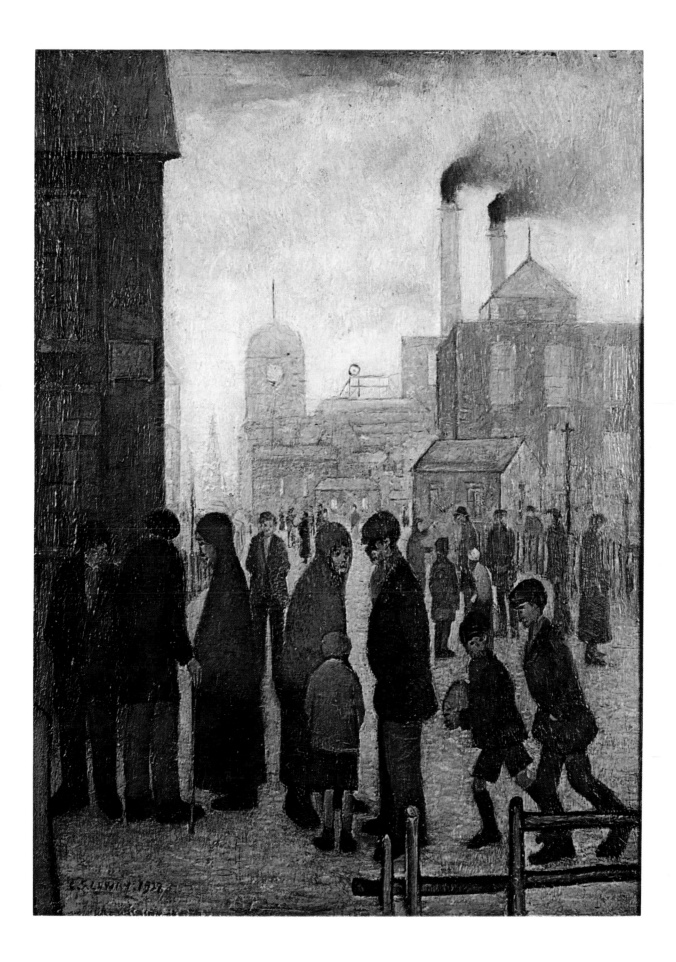

25

1929. *Oil on canvas 43.2 × 61 cm. Collection: Crane Kalman Gallery, London.*

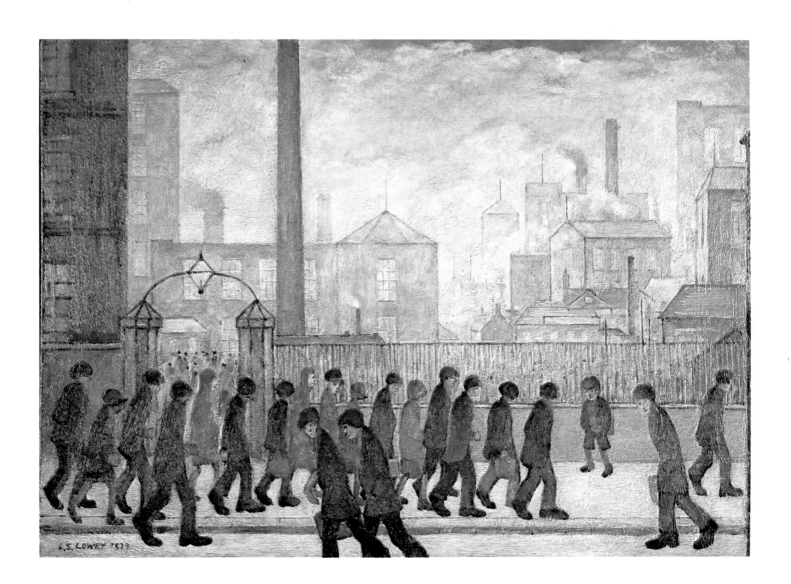

26

A MANUFACTURING TOWN

1922. Oil on board 43.2 × 53.3 cm. Private collection.

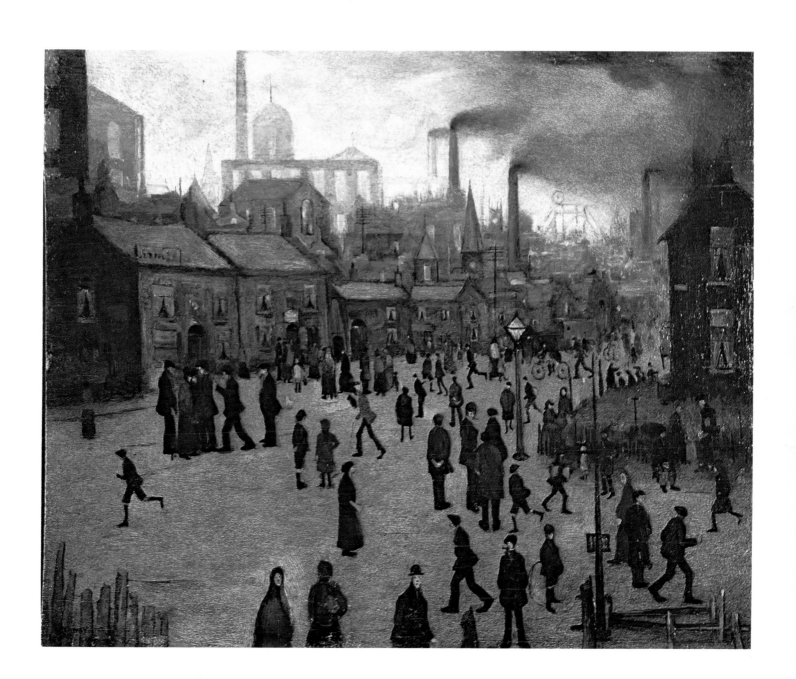

27

PASTORAL – LYTHAM

1920. *Pastel on paper. 26.7 × 37.5 cm. Private collection.*

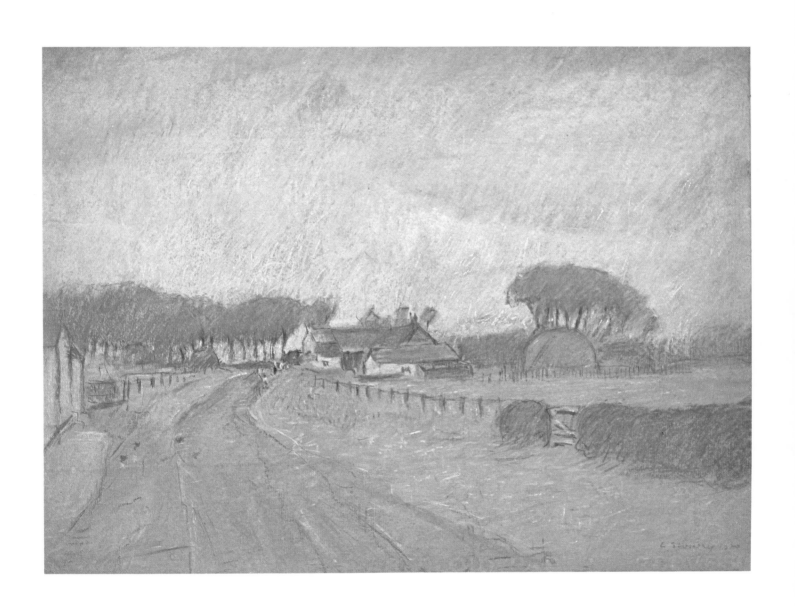

28

YACHTS

1959. *Water-colour on paper 26.7 × 37.5 cm. Collection: City of Salford Art Gallery.*

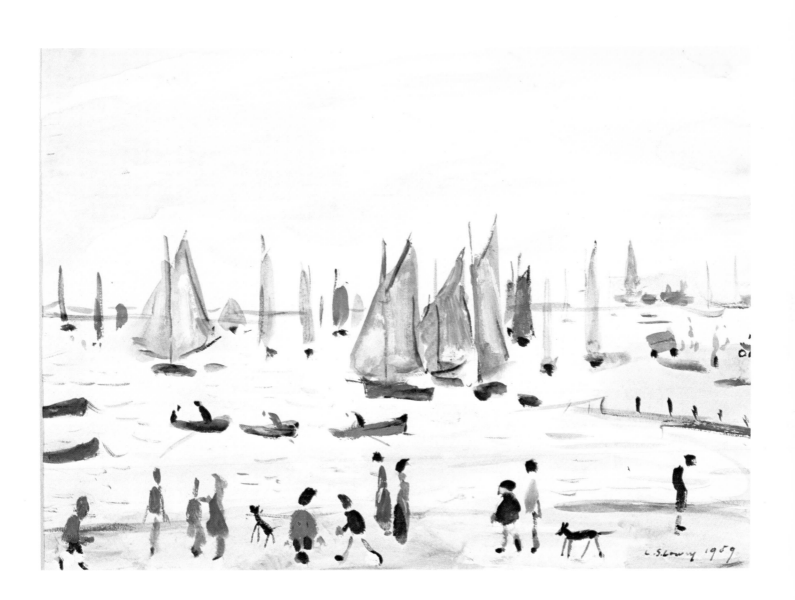

29

SEASCAPE WITH SAILING BOATS

1948. *Oil on canvas 40.6 × 50.8 cm. Private collection.*

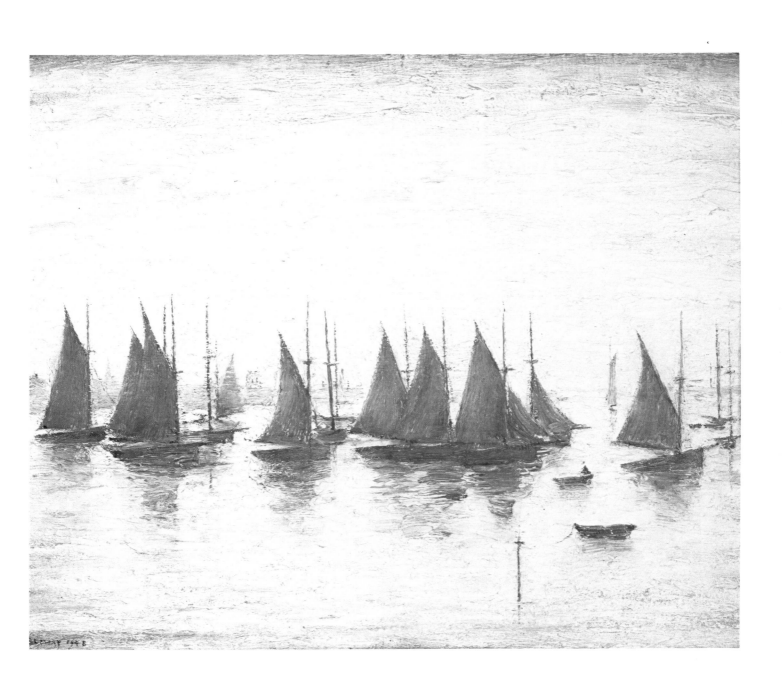

30

YACHTS, LYTHAM ST. ANNES

1920. *Pastel on tinted paper 26.7 × 36.8 cm. Collection: City of Salford Art Gallery.*

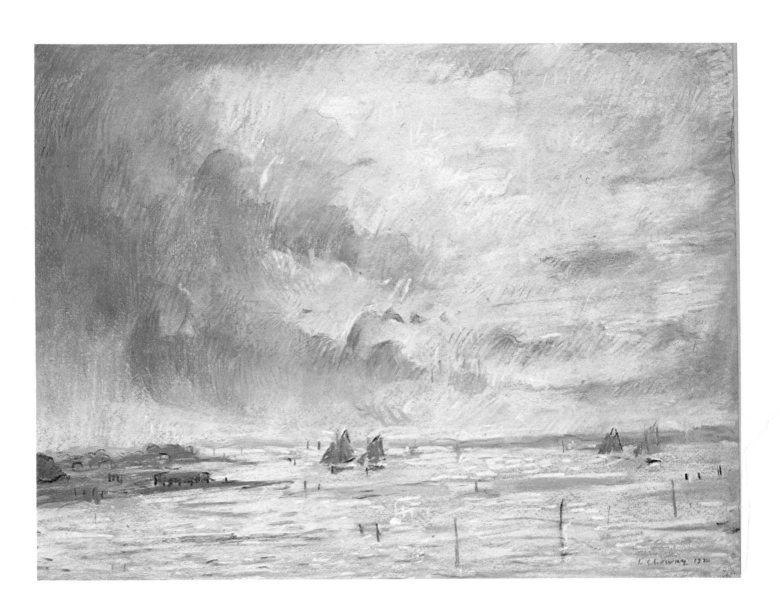

31

SEASCAPE

1950. Oil on canvas 63.5 × 76.2 cm. Private collection.

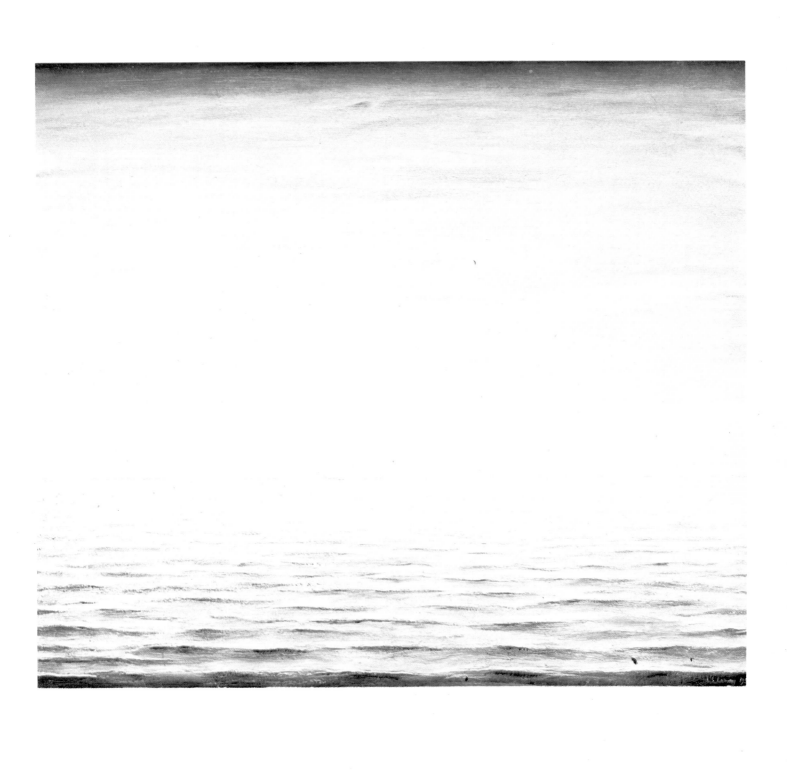

32

PORTRAIT OF THE ARTIST'S FATHER

1910. *Oil on canvas 45.7 × 35.6 cm. Collection: City of Salford Art Gallery.*

This portrait and the following are simple, painstaking and competent records, painted while Lowry was at the Manchester College of Art. His delight at my suggestion to include them in my earlier study was touching. 'Oh! how wonderful! I'm so glad, they've never been reproduced before, you know. But I would like them to be in. I really would!'

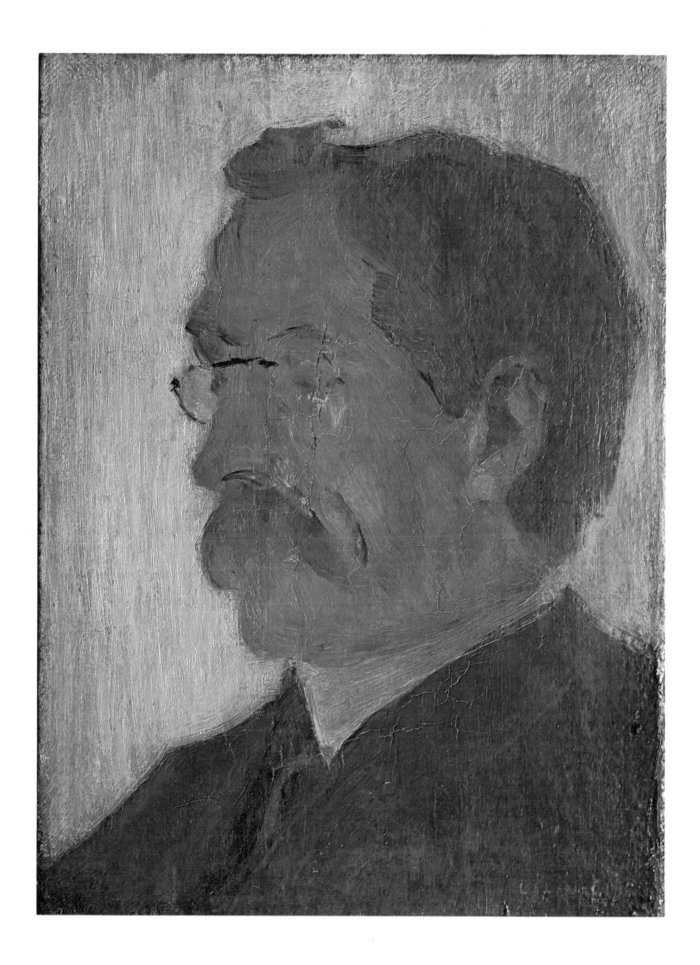

33

PORTRAIT OF THE ARTIST'S MOTHER

1910. Oil on canvas 40.6 × 30.5 cm. Collection: City of Salford Art Gallery.

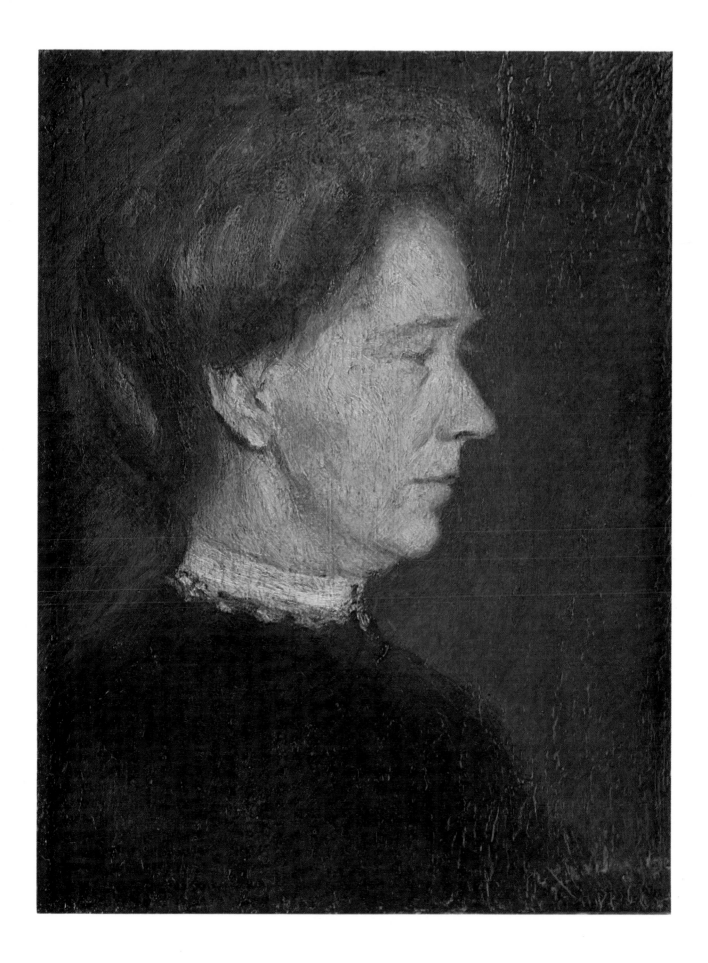

34

COMING FROM THE MILL

1930. Oil on canvas 41.9 × 52.1 cm. Collection: City of Salford Art Gallery.

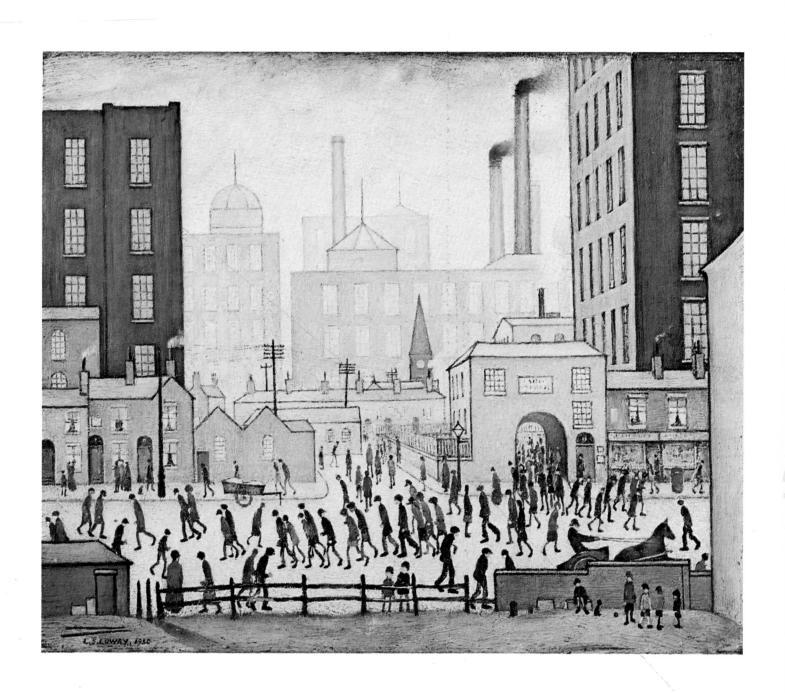

35

AGRICULTURAL FAIR, MOTTRAM-IN-LONGDENDALE

1949. *Oil on canvas 64.1 × 77.5 cm. Private collection.*

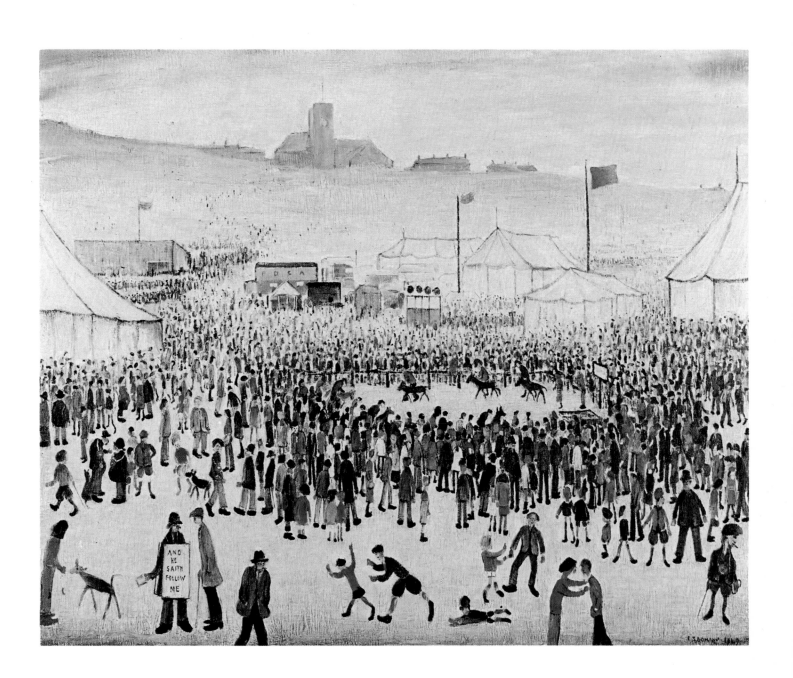

36

GOING TO WORK

1959. Water-colour on paper 27.9 × 38.7 cm. Collection: City of Salford Art Gallery.

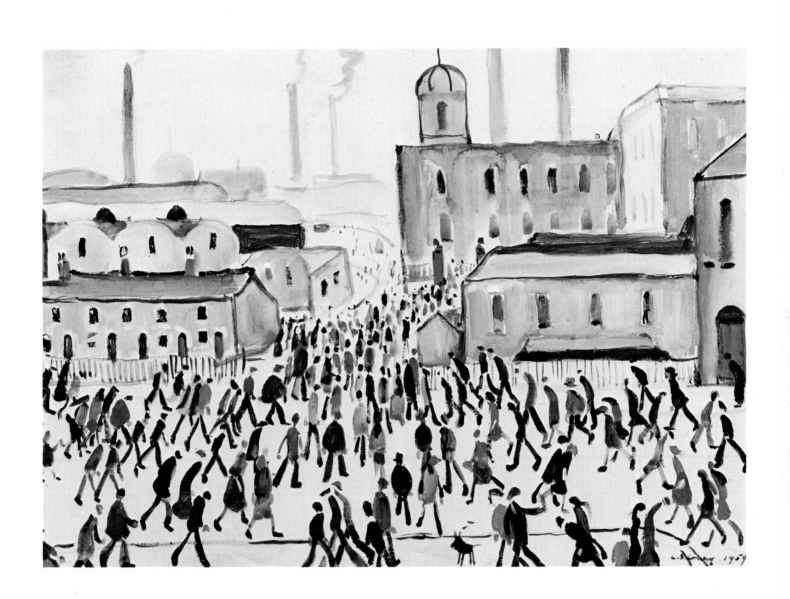

37

THE INTERROGATION

1962. Oil on canvas 45.7 × 61 cm. Private collection.

A woman is scolding a small boy for breaking a pane of glass. Another boy, the real culprit, laughs to himself behind the woman's back. His sister is ashamed of him for not owning up. They remain motionless, suspended in time and space.

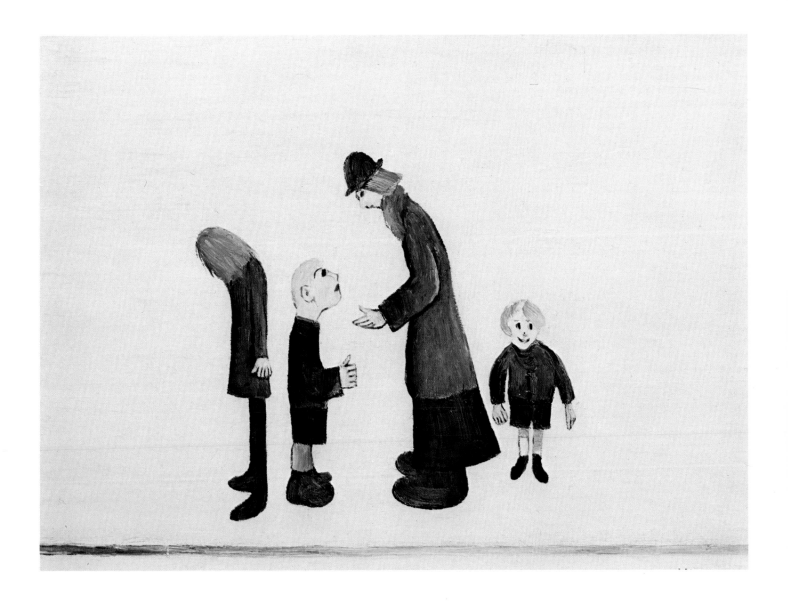

38

1942. Oil on board 52.1 × 41.9 cm. Private collection.

This was painted soon after an air-raid on Manchester. A pencil drawing from the same time is reproduced in *The Drawings of L. S. Lowry,* Plate 48.

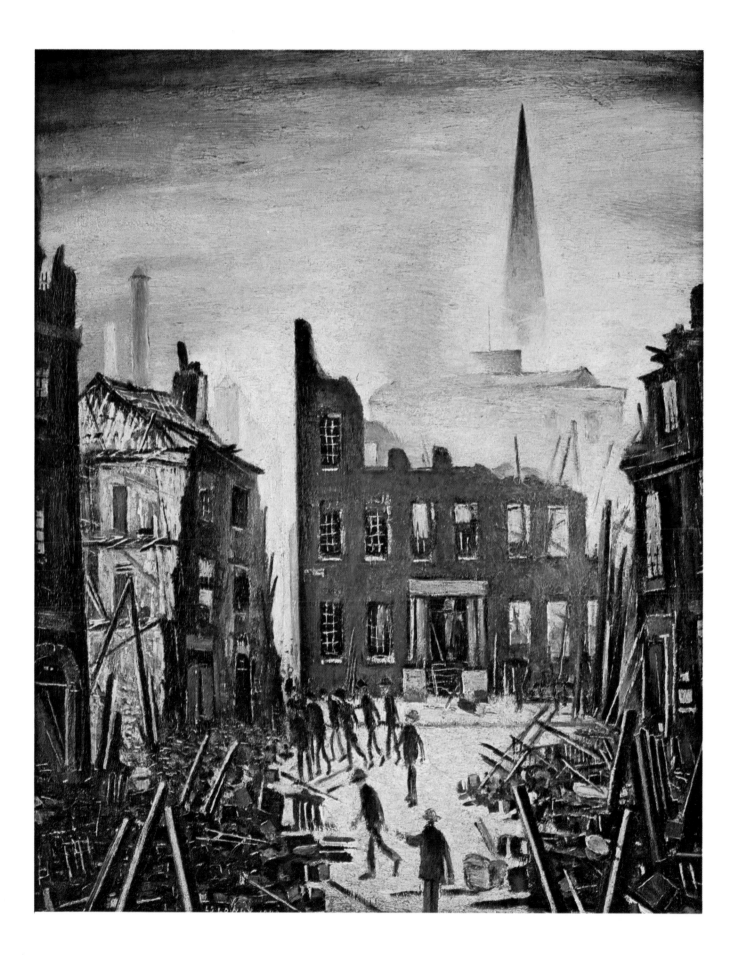

39

HOUSE IN ECCLES OLD ROAD

1913. *Oil on board 30.5 × 38.1 cm. Private collection.*

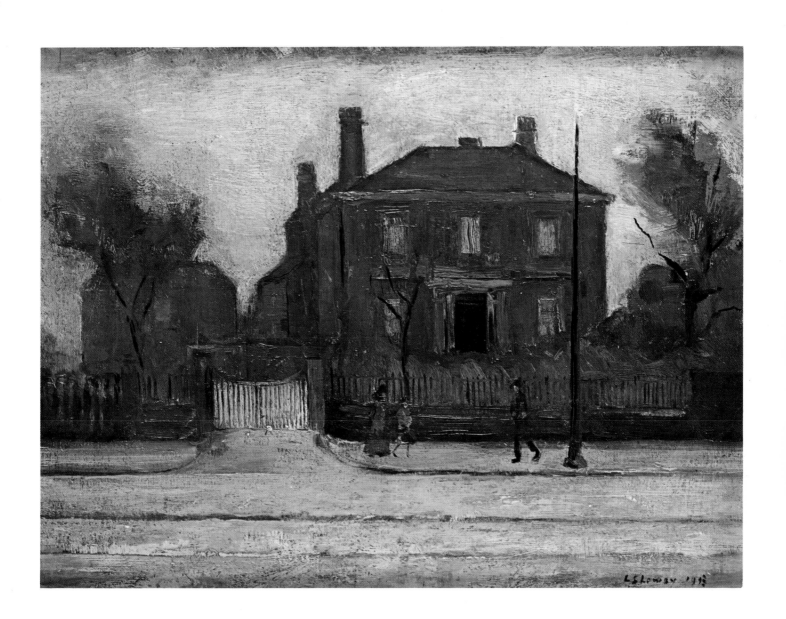

40

THE STREET TRADER

1950. *Oil on canvas 50.8 × 61 cm. Private collection.*

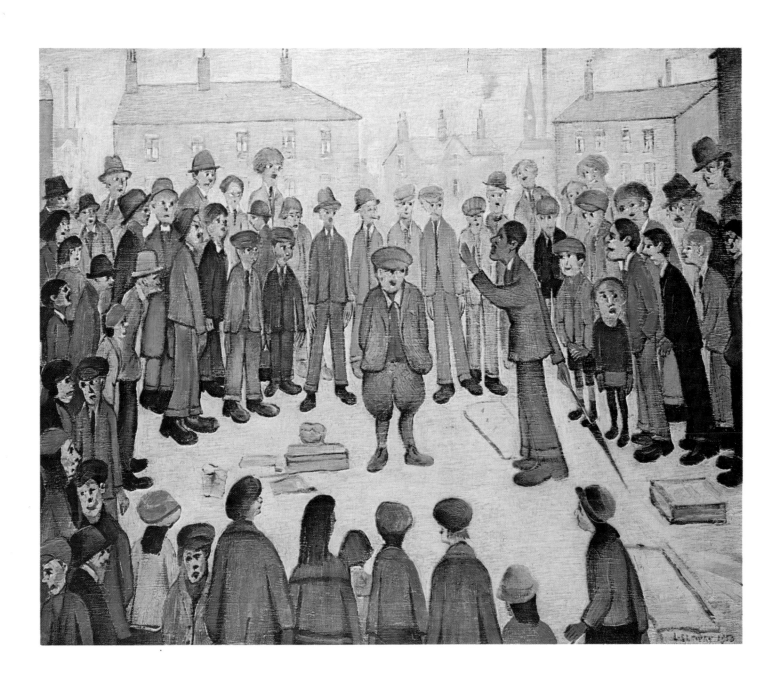

41

THE CRIPPLES

1949. *Oil on canvas 76.2 × 101.6 cm. Collection: City of Salford Art Gallery.*

'People just don't use their eyes, you know. Now take this, my friends are always arguing that I just couldn't have seen as many cripples as that. Well, of course, I didn't see them *all* at once, but I have seen them all from time to time and here, in this picture, I have simply brought them all together'.

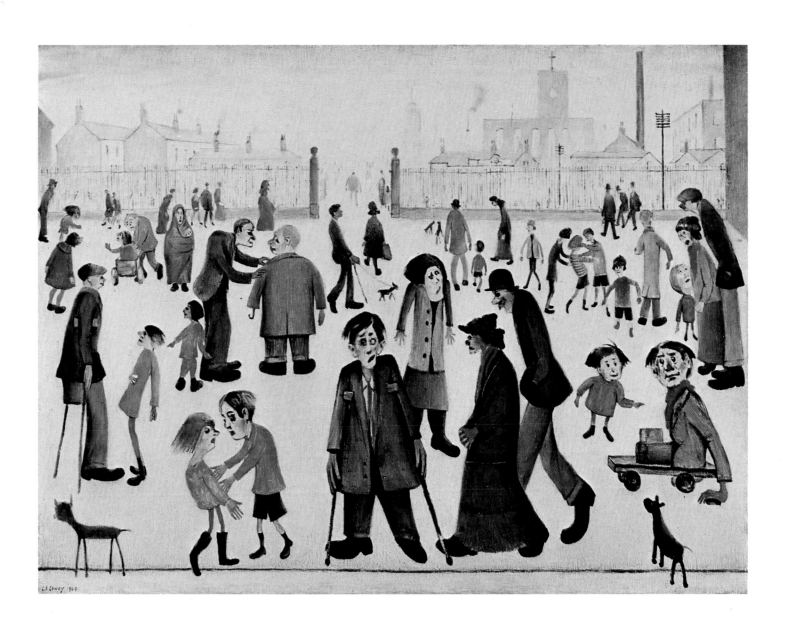

42

WAITING FOR THE SHOP TO OPEN

1943. Oil on canvas 43.2 × 53.3 cm. Collection: City of Manchester Art Gallery.

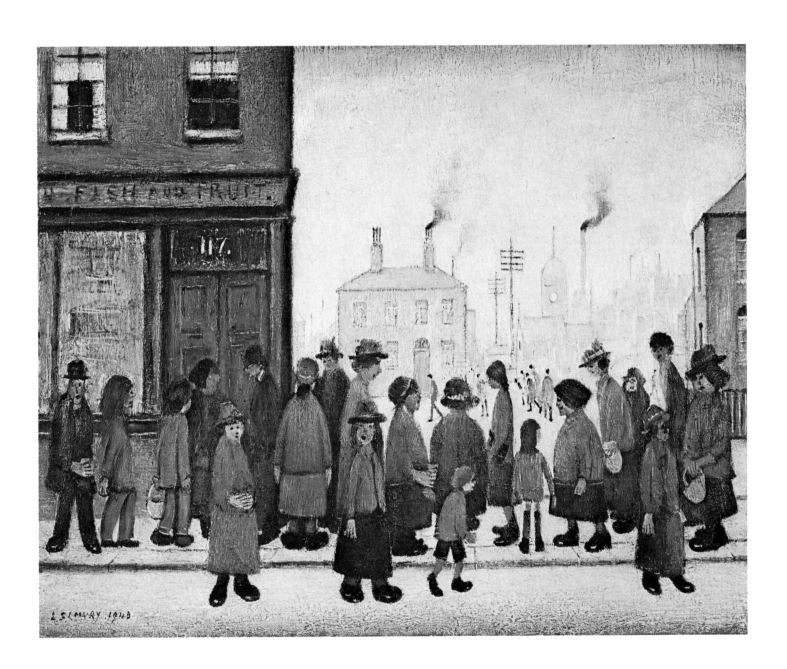

43

PORTRAIT OF ANN

1957. Oil on panel 50.8 × 35.6 cm. Collection: City of Salford Art Gallery.

This is one of a group of drawings and paintings of the same model which represented, in the mid-1950s, the artist's first portrait studies from life for more than thirty years. Plate 54 in *The Drawings of L. S. Lowry* is a reproduction of the sketch upon which the present work was based.

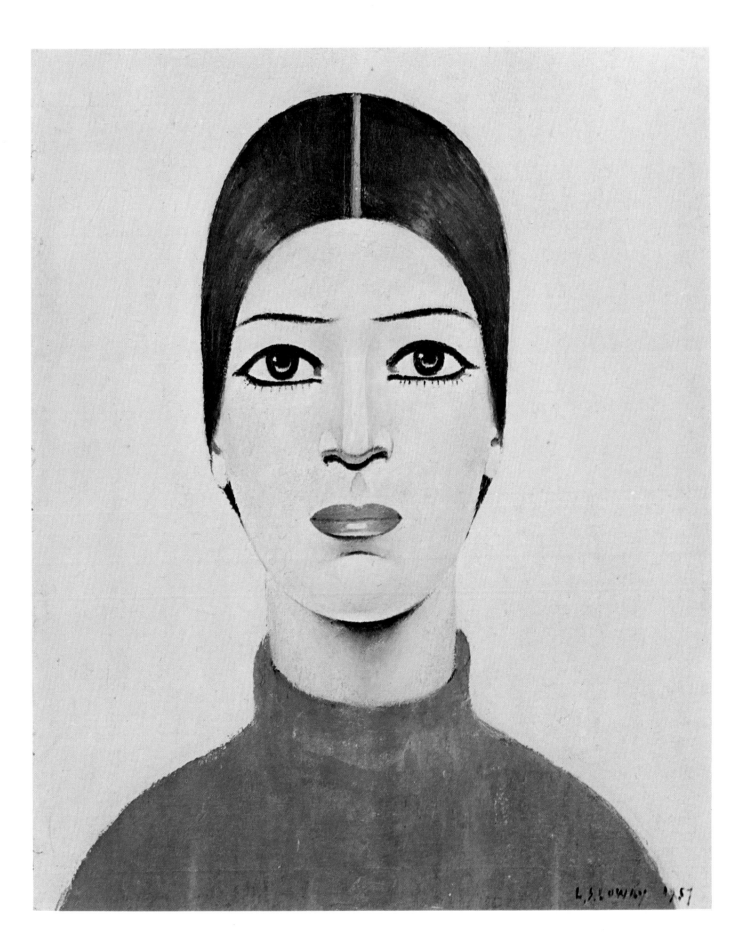

44

THE LAKE

1937. *Oil on canvas 41 × 52 cm. Collection: City of Salford Art Gallery.*

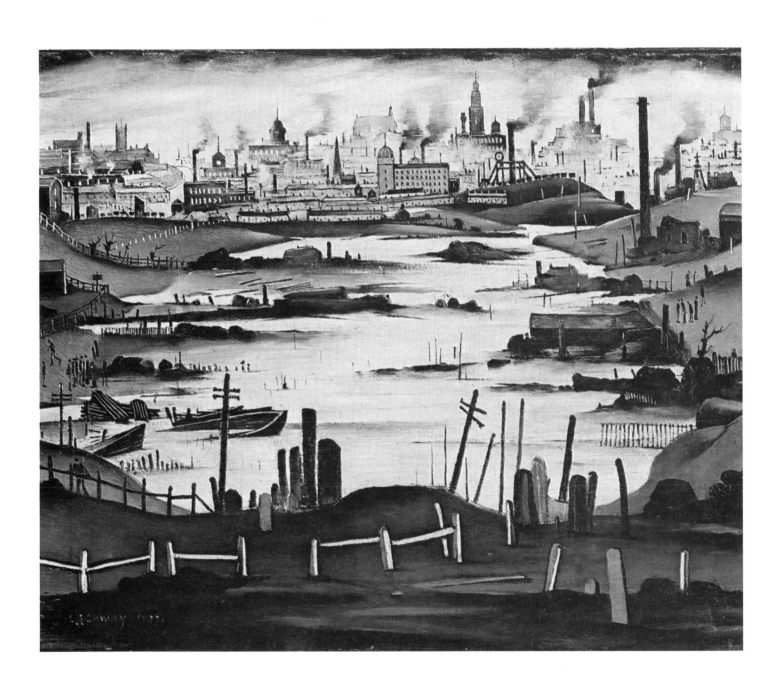

45

PORTRAIT OF A HOUSE

1954. Oil on canvas 44.5 × 59.7 cm. Collection: H. B. Maitland Esq.

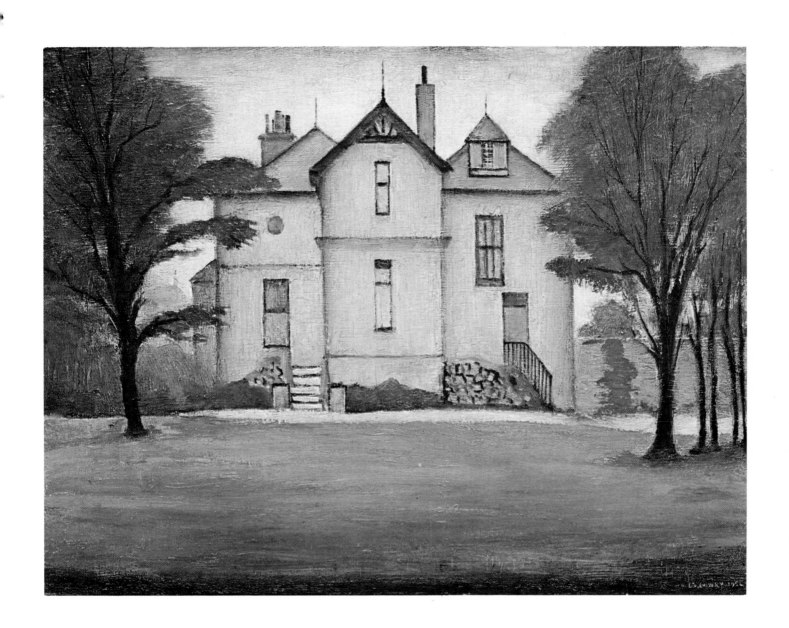

46

UNDER THE ARCH

1961. *Oil on board 31.8 × 39.3 cm. Private collection.*

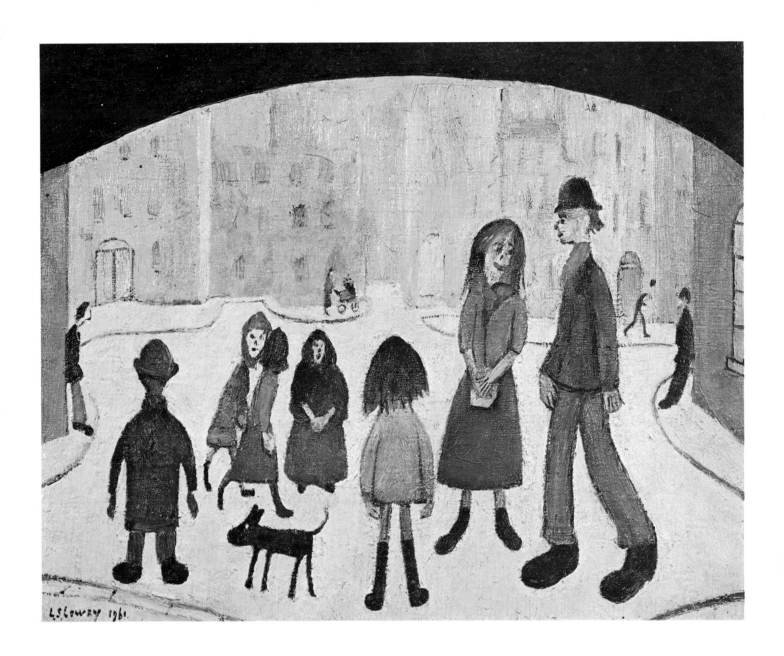

47

FATHER GOING HOME

1962. *Oil on canvas 38.1 × 25.4 cm. Private collection.*

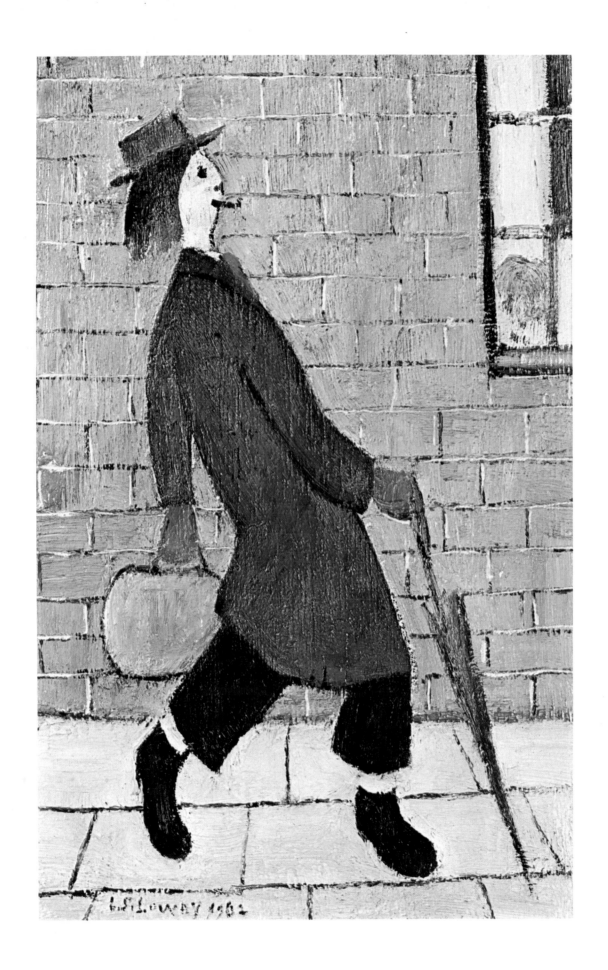